文化創意叢書　新媒體藝術

NEW MEDIA ART

藝術家

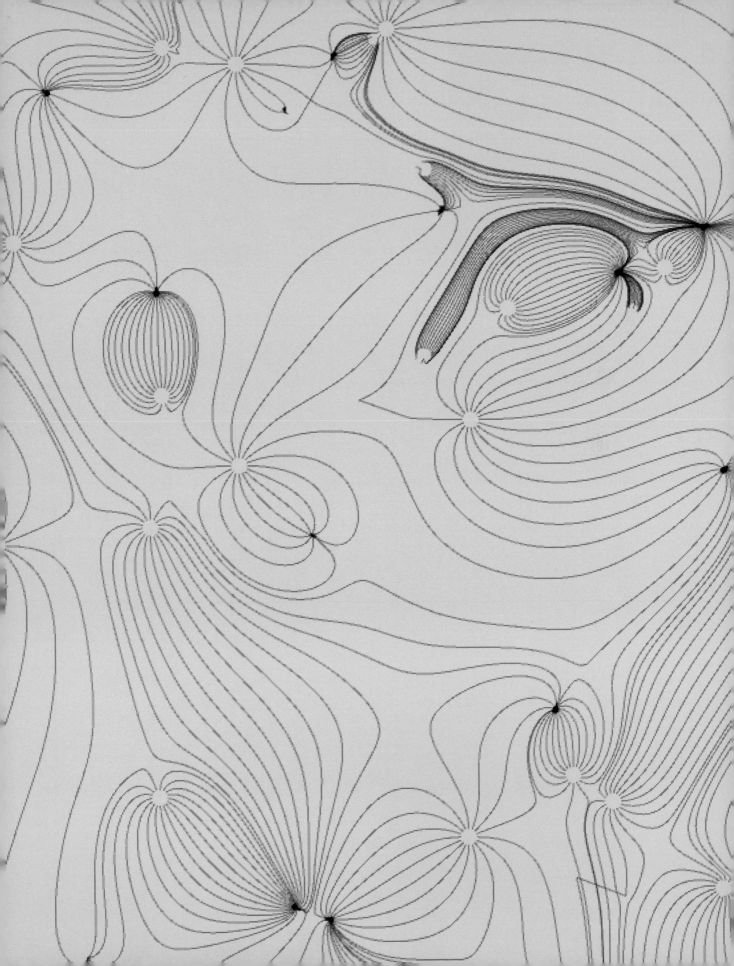

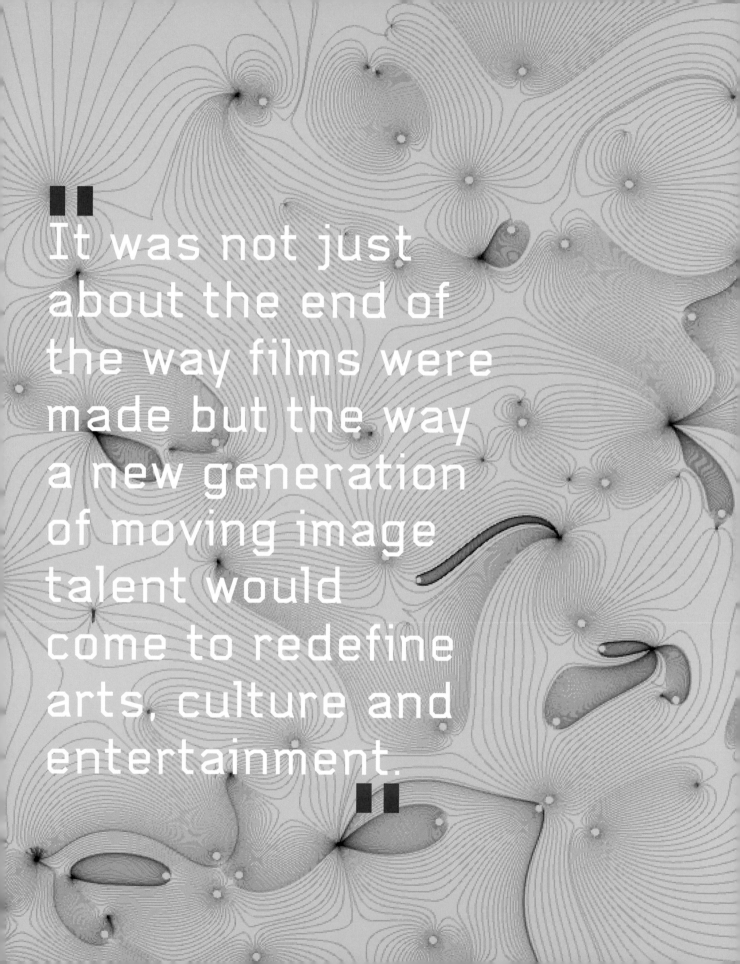

"It was not just
about the end of
the way films were
made but the way
a new generation
of moving image
talent would
come to redefine
arts, culture and
entertainment."

目次 CONTENTS

序

PREFACE

國立臺灣師範大學 校長 / 張國恩

BY CHANG, KUO-EN
PRINCIPAL, NTNU

現今世界先進國家無不積極發展文化、藝術等文化創意「軟實力」。發展文化創意，除了深掘臺灣本土的珍貴文化資產，也要與國際的頂尖科技、前端藝術相互激盪，才能撞擊出令人驚豔的創意展現。

臺灣師範大學長期以來，深耕教育人才的培育，人文藝術資源豐富，科學研究成果顯著，美術、音樂、文學、設計、體育等系所長期以來在臺灣執牛耳之地位，而近年來本校榮獲教育部 5 年 500 億「邁向頂尖大學計畫」，執行「文化創意產業知識交換樞紐建置計畫」，整合新興科技與人文藝術，建構文化創意產業知識交換平臺，並培育具備跨領域整合能力人才，以加強臺灣文化創意產業的多元化、跨領域與國際性。現在的臺師大，由以往偏重「教育產業」發展的師資培育學校，蛻變轉型至「文化創意產業」發展。

《新媒體藝術》是為本校「邁向頂尖大學計畫 - 文化創意產業知識交換樞紐建置計畫」中「國際化與交流合作」子計畫執行成果之一。本著作透過實際的國際案例與專題介紹新興形態的藝術模式，使閱讀者能夠瞭解數位藝術的發展及現況。未來臺師大也將系統性的編輯、出版不同類型的藝術、文化領域叢書，期望由臺灣師範大學領頭出發，帶領臺灣文化創意產業走向更新、更廣、更深的里程。

These days advanced countries around the world are actively developing cultural, artistic, and creative "soft power". Besides excavating precious cultural heritage, developing cultural and creative soft power must interact with top-notch international technologies and front-end arts to unveil the stunning display of creativity.

The National Taiwan Normal University (NTNU) has long been a leader in Taiwan in nurturing talents in teacher education, particularly in arts, music, literature, design, and sports, demonstrating significant scientific research achievement with rich resources in arts and humanities. The university recently received funding from the 5-year NT $50 billion grant "The Aim for the Top University Project" from the Ministry of Education to implement the "Cultural & Creative Industries, Key Junction Setting-up of Knowledge Exchange Project". The project aims to integrate emerging technology, arts and humanities, construct knowledge exchange platforms, nourish talents capable of interdisciplinary integration as well as foster diversity, interdisciplinarity, and internationality for cultural and creative industry in Taiwan. The NTNU nowadays has shifted its institutional focus, transitioning from a university that emphasizes teacher training for the education industry to an institution that nourishes ideas for the cultural and creative industry.

"The New Media Art" is one of the implementation results of the sub-scheme "Communication and Collaboration" from the "Aim for the Top University Project: Cultural & Creative Industries, Key Junction Setting-up of Knowledge Exchange Project". This work introduces and helps readers understand the development and current status of digital arts of emerging forms through international case studies and presentations. The NTNU will in the future systematically edit and publish a series of books in arts and cultures of various kinds with a view to leading the cultural and creative industry in Taiwan in going the extra mile.

國立臺灣師範大學 邁向頂尖大學計畫執行長 / 宋曜廷
BY SUNG, YAO-TING
CEO, TOWARD A TOP UNIVERSITY, NTNU

國立臺灣師範大學自 2011 年起榮獲教育部 5 年 500 億「邁向頂尖大學計畫」，執行「文化創意產業知識交換樞紐建置計畫」已將近三年。這三年來，臺師大積極執行「創意創新歷程基礎研究」、「文化創意課程精進」、「科技藝術創新展演」、「精緻文創作品產出」、「國際化與交流合作」等子計畫，並以跨領域資源整合、建立跨領域平臺為目標。

在《新媒體藝術》中，不只能夠看到新媒體藝術設計團隊與藝術節活動的簡介和緣起，更可貴的，是書中對於專案的執行過程、藝術設計團隊間的合作方式、創作概念的發想與成形、科技技術的使用都有著詳盡的描述與記錄，這些對於想發展新媒體藝術或是從事跨領域合作的讀者來說，是很難得的經驗引導，並定能使讀者獲益良多。我相信《新媒體藝術》專書的出版不只是一個年度計畫的執行成果，更是臺師大深耕藝術文化的新起點，引進世界的創意設計模組，內化為臺灣經驗，方能紮下深耕，走得更長、更遠。

Since 2011, the National Taiwan Normal University (NTNU) has received funding from the 5-year NT $50 billion grant "The Aim for the Top University Project" from the Ministry of Education to implement the "Cultural & Creative Industries, Key Junction Setting-up of Knowledge Exchange Project" for almost three years. For the past three years, NTNU has been actively implementing projects like "Project of Basic Research on the Process of innovative Creativity", "Project of Cultural & Creative Courses Empowerment", "Project of Creative Expo", "Project of Refinement Production and Project of Internationalization", and "Communication and Collaboration" with an aim to establish interdisciplinary platforms and integrating resources across fields.

In the "New Media Art", we see not only the synopses and origins of new media art groups and arts festivals, but also the valuable processes of project implementation with detailed descriptions and records of types of collaborations, modes of creative brainstorming and ideas, and use of technologies among arts groups. Readers who desire or intend to work in new media art or interdisciplinary collaboration can benefit enormously from these experiences and guidance. I believe the publication of the "New Media Art" is not just a result of annual implementation from projects; it is the new starting point of cultivating arts and culture for the NTNU by introducing the world's creative design modules and internalizing them into Taiwan's experiences for deeper and more profound development in arts and culture.

國立臺灣師範大學 總務長暨文創中心主任 / 許和捷
BY SHU, HO-CHIEH
DEAN OF GENERAL AFFAIRS & DIRECTOR OF CULTURAL & CREATIVE INDUSTRIES CENTER, NTNU

臺師大設計學系暨文化創藝產學中心自成立以來，一直致力於將原以「培育師資」為主要教學目標的臺灣師範教育龍頭轉型發展，並以「文化創新」與「藝術加值」為核心理念，定位於「文化領航‧創藝生活‧美學經濟」的發展目標，為臺灣學術研究與產業發展培育優秀的人才。而自 2011 年起，由於教育部 5 年 500 億「邁向頂尖大學計畫」的資金挹注，讓本校系有了更寬廣、更有力的執行與發展空間，並積極建構跨文化創意產業知識交換平臺、培育兼具國際性與具備跨領域整合能力人才。

跨領域的合作，在當代與未來，都是不容置疑的趨勢，而「新媒體藝術」更是橫跨科技、藝術、設計、建築、文字、圖像、音樂、動畫和影片等領域，是跨領域整合人才不可錯失的重要一環。本校設計系很榮幸能夠聘請 onedotzero 亞洲區黃茂嘉總監擔任本系教授，2012 年黃教授帶領學生集體創作，於本校行政大樓外，展現戶外高流明投影技術呈現出新媒體藝術巧思，呈現邁向頂尖大學計畫第二期成果。而 2013 年本校設計系更與表演藝術研究所合作演出－改編自諾貝爾獎得主高行健的《山海經傳》華麗搖滾音樂劇。以上皆為本校系在跨領域合作上努力的具體成果。現在，更要出版關於《新媒體藝術》的專書，編輯、收錄包含 onedotzero 等國際藝術團隊的案例介紹與精彩照片，讓讀者能夠更深入、更廣泛的探索新媒體藝術。

臺師大設計學系暨文化創藝產學中心將會在跨領域的範疇繼續深耕，並期許有更多國內外大專院校能夠跨國界、跨校系的與我們一齊開拓臺灣文化創意與藝術的未來。

Since its founding, the Department of Design and its Cultural & Creative Industries Center at the National Taiwan Normal University (NTNU) has been committed to transform its initial primary mandate of being the leader in teacher education and training in Taiwan to being an institution with cultural innovation and art enrichment as core values. The new goals are to become the forerunner in cultural innovation, to nourish creativity in life, and to invent aesthetic economy to foster fine talents for academic research and industrial development in Taiwan.

The influx of funding from the 5-year NT $50 billion grant "The Aim for the Top University Project" from the Ministry of Education since 2011 empowered the NTNU considerably to actively develop and construct cultural and creative industries knowledge exchange platforms, and foster talents capable of international and interdisciplinary integration.

Interdisciplinary collaboration is the indisputable trend now and in the future. The "New Media Art" is an important field not to be missed that integrates technology, arts, design, architecture, text, images, music, animations, and films, etc. The Department of Design is honored to have Huang Maojia, the onedotzero Asia Director as a new faculty member. In 2012, professor Huang led students to collective creation outside of the Administrative Building, displaying high lumens projection technology of the new art media ingenuity and showing the phase II results of the Aim for the Top University Project. This year, the department also collaborates with the NTNU Graduate Institutes of Performing Arts to perform shows adapted from the Nobel Prize winner Gao Xingjian's classic glam rock musical – "Shan hai jing zhuan". These are efforts of interdisciplinary collaborations made by the NTNU. The publication of the "New Media Art" containing case presentations and amazing photos from international arts groups like onedotzero provides readers with a deeper and more extensive exploration of the new media art.

The Department of Design and its Cultural & Creative Industries Center at NTNU will continue to cultivate in interdisciplinary fields and hope to have more cross-department and cross-border collaborations with local and foreign institutions in furthering cultural innovation and future of art enrichment in Taiwan.

相關論述

ESSAYS

onedotzero
數位藝術和發展中的文化領域
BY SHANE RJ WALTER

當你像 onedotzero 一樣到 2011 年為止已經營了 15 年，即到達一個象徵性的里程碑，你便很自然的會被要求去回顧你的過往。但我倒覺得這是個異常艱鉅的任務，畢竟我們的天性就是著眼於未來。

從第一天起，我們便計畫著去影響、去革命，進而去改變事物；並在工作模式的創新上、表達方式的建立上，以及在支持新型態創作者的倡導上，皆不時注入各種力量與催化劑。從「多媒體」被視為古怪名詞的初期，到如今已是流行通用詞彙的年代，這段瞬息萬變的時光裡，onedotzero 卻始終堅定固守著自身在數位工作領域的使命。

展出數位藝術和設計作品是 onedotzero 自成立起就持續進行的工作，其始於家用電腦革新時期的 90 年代中葉，並迫切期待數位藝術和設計不只能在螢幕上被動的呈現，其無論大小，都能將它們從銀幕上被移動到環境中，並透過電玩、互動式 CD 光碟或網際網路作互動式介紹，故不論在軟體或者硬體上，它們都扮演著開啟數位時代冒險的重要角色。

生成一個新的數位創意型態，必定需要伴隨著一種帶有數位新理念的思維以及態度，但在當時就好比像是英國一戰時期的奇想畫家 Heath Robinson（荒地魯濱遜，在當時以繪畫創作發明有趣的奇想儀器留名），藉著注入龐克與嘻哈元素的導航器馳騁開疆。而憑著這種置之死地的覺悟來推翻並重建邏輯的過程，反而是我們認為在貫徹自我理念上最必要也是最健全的經歷，且無庸置疑的，這也是我們認為在整個過程中，最令人感到興奮與熱血沸騰的部分。

「很簡單，我們無法踰越未來，但新科技產品帶來的改變則會隨之生成，且永遠不會停止。」onedotzero 發起人之一的 Matt Hansen 於 1997 年，即第一屆 onedotzero 藝術節時發表的〈賽璐璐時代的終結〉散文中已為我們下了這個註解。 這類似宣言的論述在當時對

傳統影片產業及其製作思維挑起了負面的漣漪。我們試著快轉回到那個時代的背景下，當時的影片產業確實有眾多對融入新科技方式感到抗拒且無法接受的，但觀其現今，其改變並沒有讓影片產業的傳統失去傳承，反而卻幫助新世代的動態影像新血去對藝術、文化，與娛樂產業重新定義。

不可否認，數位文化已觸碰到現今人類生活的各樣環節。而 ondotzero 則致力於將目前在數位藝術與設計中生成的各項發展一一呈現出來，並透過從國家級博物館、藝廊、夜店到各種藝術節去反映出數位文化的進程以及日後的趨勢。更為重要的是，需將其與現存的藝術與設計作品結合，交流出不同的語彙，進而拉近更多廣大的族群並創造他們對其更深層的認知。

onedotzero
DIGITAL ART AND THE DEVELOPING CULTURAL TERRAIN
BY SHANE RJ WALTER

When you reach a symbolic milestone, like onedotzero reaching 15 years in 2011, you are naturally asked to look back. I have always found this a difficult task - by our very nature we are looking at a future vision in everything we do. From day one we have set out to influence, shake up and change things; provide a catalyst for invention and new ways of working, new modes of expression and championing a new kind of creator. From quaint terms such as multimedia to the lexicon lists of buzzwords today, onedotzero has always played firmly in the digital playground.

Exhibiting digital art and design is something that onedotzero set out to do from day one. onedotzero was conceived at the start of the desktop digital revolution in the mid-1990's and with it a strong desire to show digital art and design not just on a passive screen – whether it be big or small – but to take this off the screen and into environments and introduce interactivity be it in computer gaming, interactive CD-ROMs or web based.

The digital tools, both soft and hardware, opened up this new adventure. A new digital way of thinking and attitude were the vital ingredients to allow this new kind of creation to happen. It was Heath Robinson riding through the Wild West frontier with a Punk-infused Hip-Hop score. It was a cut and paste, hack and clash rethink we felt was healthy, necessary and so undeniably exuberant and exciting at the time.

onedotzero co-founder Matt Hanson's introduction essay 'The End of Celluloid' in the first onedotzero festival catalogue in 1997 pretty much set out our stall. The future will not be the past, simple enough, that change is happening and it won't stop happening. It was very much a manifesto against standard film* using the new accessible technology that was arriving. Fast forward the years and onedotzero's key messages look almost obvious today but there was much reluctance and resistance at the time to this way of thinking. It was not just about the end of the way films were made but the way a new generation of moving image talent would come to redefine arts, culture and entertainment. *[You can substitute film for any other medium here.]

It is undeniable today that digital culture has touched so many parts of our lives. onedotzero is about presenting the latest developments in digital art and design today, a reflection on how far digital culture has come and where it can be presented from national museums to galleries, clubs and festivals. It is also important to put this in context and draw a dialogue between this work and existing collections of art and design, both to reach a wider audience but also create a deeper understanding. Decode: Digital Design Sensations exhibition at the V&A Museum, co-curated by and in collaboration with onedotzero, was a seminal moment in onedotzero's history not only working with such an august institution but creating a platform for this new work to reach a wider audience in a credible venue.

> **It was not just about the end of the way films were made but the way a new generation of moving image talent would come to redefine arts, culture and entertainment.**

There has never been a more important time to look at the practice and work from computer and digitally driven creators than now. Digital pervades all aspects of our lives today and there is a desire to understand what that means. The work onedotzero champions, and importantly has a track record of commissioning, allows us to showcase current trends in contemporary digital design practice. It highlights issues that this merger of art and technology throw up in our everyday lives. Such as the over abundance of information and how we come to deal with this through data-visualisation, the real and natural versus the artificiality and augmented, surveillance and the traces we leave behind, the importance of play and code as a material for artists to work with as sculptors work with clay etc.

We are all intrinsically linked through a system of networks whether by telecommunications, the Internet or surveillance devices and mechanisms. We have never been so 'connected.' The Internet has given artists and designers new platforms for production, interrogation and dissemination but also the ability to tell personal details and scenarios often of the most personal nature. This element of sharing has transformed the Internet in recent years to what we call web 2.0 and a social media platform. Some of the works data-mine this information to present this back to us so we can see literally emotional maps of parts of the Internet and parts of the world. Data visualisation is becoming increasingly popular and important as we wade through streams of information in our lives we need to be able to understand it.

This networked world provides the basis and tools for works that are multi-sited and global. The networks are saturated with the traces of our lives: messages we send, blogs we post, and borders we cross. New technologies have a lasting memory and designers are using these memories as a basis of new works. They are taking our digital tracks and traces and translating them into readable and understandable visualisations, teasing out the threads of our digitised activity. Two commissions by onedotzero explore this idea of network, and how it can be used to positive affect. The 2009 onedotzero festival identity harvests and visualises global conversations created with code by Karsten Schmidt. The collaborative work Plasticity creates a local network that remembers and echoes user inputs taken from the firing of neurons in the human brain.

Whenever artists or designers use new tools there is always a period of nervousness to think the tools or techniques are the main driver in the work to some extent. There does need to be a period of experimentation – to find the original voice using new techniques and ways of working but there is strong work by digital native artists that have emotional impact and resonance.

Joanie Lemercier of AntiVJ takes a very proactive approach to developing projection mapping through research and development. onedotzero commissioned Eyjafjallajökull which both crystalized Lemercier's voice but also delivered an epic work of impact that questions our fragile existence and the power of nature in our increasingly techno world.

onedotzero has a considerable track record of innovative commissions in a variety of media with artistic talent in an often developing period of their careers. The means of production has changed for most people but this does not diminish the role of the artist. The most interesting creators will get the best results to convey their ideas from the tools of the day and this area is no different. Computer and digital technologies make collaboration easier and we can see this from collectives such as Troika or UVA as well as jointly authored works like Plasticity and the rise of the use of open source technology by Hellicar & Lewis.

onedotzero is very much about showcasing great work of great designers, artists and creators in this field but also creating a platform for the work to be discussed and enjoyed at many levels. It is as much about demystifying the magic of digital as well as showing that the work can be poetic, emotional and poignant. Interactivity is an important factor in breaking down barriers and creating a confidence to get audiences fully engaged and involved. Museum contexts, to a certain degree are also being challenged – in Decode at a museum like the V&A for example you could touch the work, photograph it, take some of it home with you, engage with it outside the museum hours, even upload your own creations and remix the identity. This fosters an open mindedness and understanding of the area twinned with a fun, informative and touching experience for visitors.

Over the years, onedotzero has exhibited this work internationally in many different contexts. The greater Art market does need to develop an understanding of what it is that they are dealing with and buying in relation to these new digital artworks. If you go to the theatre, you expect to see something live just on that night; you certainly don't expect to see a cinema version of it. Digital art has a sense of actuality about it. However, there is some kind of limit to this – it won't last forever, which is somehow also part of its

■■
onedotzero is very much about showcasing great work of great designers, artists and creators in this field but also creating a platform for the work to be discussed and enjoyed at many levels.
■■

beauty. If you buy an oil painting, it will last a very long time and has a recognised value.

There is a growing interest in digital art in the traditional Art market because a lot of people have grown up with moving image media, gaming and progressive new media art in the past twenty years. These people are in their forties and potentially are now thinking about buying art. The question is how to address this demand because I don't think that this form of art will simply disappear– it is going to increase and that sales and expertise in this area need to increase rapidly, too. A few galleries are have an understanding of this area such as DAM in Berlin and Bitforms in New York even though a growing number of others are breaking through.

In terms of legacy onedotzero has shown the way for a more open, collaborative creative landscape that is about the convergence of technology but more importantly ideas. These ideas manifest in a number of media outputs from linear moving image on a multitude of new and traditional platforms right across interactive, responsive, immersive, augmented environments.

onedotzero has been described by the Guardian Newspaper in the UK as being "as close to the future as you can get". This illustrates the fast paced, insatiable need for the new and the next that we all face nowadays in the creative sector. More so when you set yourself out to showcase fresh talent, nurture innovation, ping out new ideas and influence the creative cultural sector like the onedotzero festivals, events and projects have done over the last decade and half.

Being part of the transition generation from analogue to digital, what excites me now is the new wave that have grown up within this digital culture.
These are the ones that will reshape and define our future. Their cross media thinking and attitude are attuned to

collaborative production, ever newer hybrid forms that mix and meld cinema with clubbing, theatre with photography, graphics with live music, fine art with computer gaming without any tech hang ups.

onedotzero is designed to be a place for experimentation and invention but also collaboration where its engine is convergence. An ever-evolving creative playground where art forms have collided, hybrid creators have risen and more importantly the appetite of the audience has skewed to demand a more progressive and diverse entertainment experience. tWe hope that onedotzero is able to map the next evolution as we have in the past taking progressive creators and audiences with us to an exciting future.

Shane RJ Walter
onedotzero Co-Founder / Creative Director

新媒體藝術

NEW MEDIA ART

關於新媒體藝術

新媒體藝術最早可以從 19 世紀中葉攝影術的發明談起，但多數人較認同 1920-1950 年間在歐美陸續出現的、融合科學技術的藝術型態才是新媒體藝術的開端。例如 Jean Tinquely 在 1960 年創作的動力雕塑〈向紐約致敬〉，就具有當代新媒體藝術的雛形了。在亞洲，臺灣的新媒體藝術的發展較日本晚許多，有很長一段時間觀眾把新媒體的作品視為較陌生的經驗，在觀賞時的接受度也與傳統的創作媒材（如油畫）存在落差。但近年來在國際藝壇及中國新媒體藝術發展的刺激下，年輕觀眾的接受度提高，才成為熱門討論的藝術型式。

近年來資訊流通快速，歐美及日本新型態的創作資訊能及時在網路上觀看。臺灣全國美展也將新媒體藝術納入收件的類別了，北中南區推動新媒體藝術的公共空間逐一設立，讓國內觀眾有更多接觸的機會。從連續幾年的公費留學考試名額，也可見臺灣文化部對此學門的重視。此篇整理我對新媒體藝術的認識，作一簡要分享。

首先，從 "New Media Art" 字面上，就可明白新媒體藝術的概念離不開對 "Media" 的討論。Media（媒體）這個字，是 medium（媒介）的複數型態。根據牛津辭典，「媒介」(medium) 釋義為：「某物賴以生存或活動或傳播的介質或環境」。自古以來藝術家就是使用「媒介」(medium) 來創作，如我們較熟悉的油畫、水墨、紙、泥土等都是媒介。媒介是藝術家再現心境、寄託情感，表達洞見使用的介質。然而檢視過去，不難發現「媒介」在藝術史上有固定的生態週期，它們被發明；被使用；然後被取代，很少有媒介能一直長久被使用下去。例如，隨著印刷科技發展的版畫藝術，就是很好的例子。在西元 16 世紀，盛極一時的木刻版畫 (Intaglio) 被銅凹版畫 (Etching) 所能創造出的細膩描寫效果所取代。而在 19 世紀，因應發行報紙對成本及速度的需求，平版技法又幾乎完全取代了銅版，成為更具經濟效益的印刷技法。可見不同時代的媒介 (medium)，呼應著不同時代的需求。它們不僅是一個時代科學與技術的標記，也能在不同的時間點，召喚屬於一個時代背景的美學和知識。

ABOUT NEW MEDIA ART

Earliest new media art from the 19th century invention of photography talk, but most people agree that 1920-1950 years than in Europe, emerging, and integration of science and technology is the new media art artistic patterns beginning. In 1960 for example Jean Tinquely creative kinetic sculpture "Tribute to New York", it has contemporary new media art shape up. In Asia, Taiwan, the development of new media art much later than that of Japan, there is a very long time viewers of the new media works as unfamiliar experience in acceptance when viewing it with the traditional creative media gap exists. But in recent years in the international art world and China to stimulate the development of new media art, the young audience to improve acceptance before they become popular discussions of art style.

In recent years, rapid flow of information, Europe and Japan, the creation of new types of information can be viewed on the Internet in a timely manner. Taiwan's National Art Exhibition will also be included in the new media arts category of recipients, northern, central region to promote the new media art in public space set up one by one, so that the domestic audience to have more contact. From several years of studying abroad exam places, but also shows Taiwan's Ministry of Culture of the importance of this discipline. Cipian organize my understanding of the new media art, a brief sharing.

First, from the "New Media Art" Literally , you can understand the concept of new media art inseparable from the "Media" discussion. Media This word is medium of the plural form . According to the Oxford Dictionary, "medium" definition is: "something or activities or to promote the survival of the media or the environment ." Since ancient times, the artist is to use the "media" to create, as we are more familiar with painting, ink, paper, clay, etc. are medium. Media is the artist reproduces mood, emotional sustenance , expressing insight media used. View past, however, difficult to find "medium" in art history with a fixed ecological cycle, they are invented; being used; then be replaced, there is little media could have been for a long time been using it. For example, with the development of graphic art printing technology, is a good example. In the 16th century AD, a tremendously popular woodblock prints by copper intaglio can create the effect of delicate depiction replaced. In the 19th century, in response to a newspaper based on the cost and speed requirements, lithography techniques has almost completely replaced the copperplate, become more cost-effective printing techniques. Visible different eras media , echoing the different needs of the times . Not only are they an era of science and technology, marks, but also at different time points, summon the aesthetic part of a background and knowledge.

案例介紹 - 藝術活動

CASE STUDY - EVENTS

帶著對數位影像未來的願景，onedotzero 藝術節始於類比時代末期的 1996 年，由 Matt Hanson 擔任第一屆藝術節總監，他和當時亦為該藝術節製作人的 Shane Walter 都在探索如何利用這些新的數位產品，在影像的前、後期製作中帶來更多新的影響，並貫穿整個製作的思維與流程，進而將視覺效果的創作效能以及在視覺傳達的呈現上可以更加精準且更多樣性的觸碰人們的感官體驗。 故從首屆起，該藝術節就著眼在各種視覺創意對其影像表現之影響與衝擊，包括可能像是以極具美感的平面設計、插畫、或是一些新媒體的繪畫作品…等切入，而不只是將數位工具單純地看作是個降低製作成本的新時代工具。另外，onedotzero 相信在創意產業領域發掘新作品的唯一途徑，就是鼓勵創新。

在秉持此理念及如上述的多元思維，

onedotzero 與該藝術節將各個在當時毫無交集的創意領域間，皆鋪設了相聯結的線路，諸如在電影產業、電玩遊戲業、動畫業、夜店、電子音樂、動態視覺，以及網站開發者這些擁有獨自族群卻相互沒有接點的個體之間，開啟了不同思維的創意交流與碰撞，而 onedotzero 便成為了一個創意產業間互相溝通接觸、分享想法、傳遞訊息、交流技術和理念的一個跨界平臺。

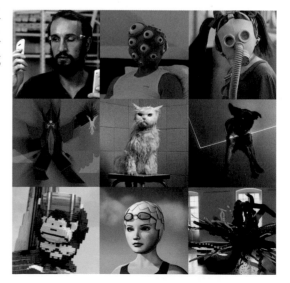

The onedotzero festival began life in 1996 with the first festival director Matt Hanson and a vision of the end of celluloid. Along with Shane Walter who produced the first festival, they were both keen to explore how the design sensibility of these new digital desktop tools could add a new perspective on filmmaking, film language and narrative using a digital, non, linear and highly visual approach.

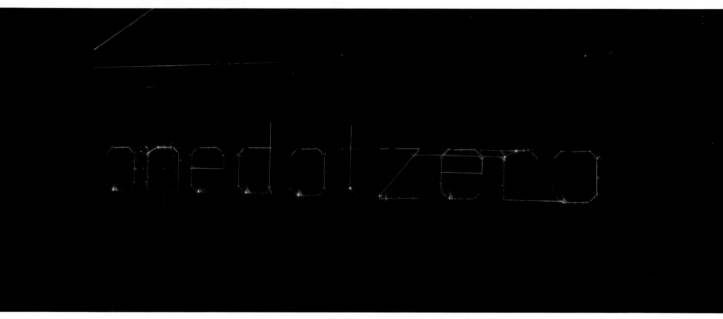

Rather than looking at new video technology as a means to make cheaper versions of what already existed, the festival took a decided look at the language of cinema and whether it can be influenced by a very visual aesthetic hailing from graphic design, illustration and new media. From the very first year onedotzero was a producing festival, the only way to see new work from this section of the creative sector was to encourage people to make something new. There was a strong desire to create a creative collision between what were at the time very different areas such as computer gaming, film, club culture, motion graphics, animation, electronic music, web developers - who all had their own niche followers but were almost ghettoised and segregated.

Spotting the links and creating a forum made these groups culturally connected and creatively aware of the potential crossovers and future opportunities. onedotzero became a crucial destination for people across the creative industries to meet in one place, to rub shoulders, share ideas, pass on language, tools, techniques and ideals.

幾年下來 onedotzero 及其藝術節便掌握了
這不斷變化的數位生態,並將如 Michel
Gondry、Spike Jonze、Jonathan Glazer、Chris
Cunningham、Mike Mills…等這些在當時非指
標性導演的初期作品,從鮮為人知的一般宣
傳類影片轉變為被推向高峰的得獎巨作。而
有趣的是,這些影片也被其他許多截然不同
的產業加以應用,如 Universal Everything 和
H5 工作室製作的動態圖像作品、動作遊戲名
作鐵拳 (Tekken) 和旋律神作遊戲 Rez 的預告
片,UVA 和 Karsten Schmidt 的互動藝術裝置、
Jason Bruges 工作室的中介建築、DJ Yoda 和
the Light Surgeon 的現場視聽表演、角色設計
師 Jamie Hewlett 和 James Jarvis 的創意作品;
還有唱片廠牌 Warp 和 Ninja Tune 以及日本動
漫人物首展等 ...,造就了充滿視覺、聽覺和
創意心靈饗宴的新型態藝術節。

該藝術節的活動安排主要以四大方面為主,
即:短片放映;裝置藝術;現場聲光展示,
以及(機會)教育。這些活動每年為鼓勵來
自創意產業的新人、藝術家或創作個體, 以
「動態影像冒險」為前題,並透過每年舉辦
的免費公開徵選,選出將於藝術節中展出的
作品,提供他們在藝術節公開呈現其創作的
機會。

Over the years onedotzero and the festival has mapped this shifting digital terrain, showing the first or early works of Michel Gondry, Spike Jonze, Jonathan Glazer, Chris Cunningham, Mike Mills, all considered not to be proper film directors, transitioning from promos to award winning feature projects. The interesting aspect however is that these were shown alongside motion graphic work from studios like Universal Everything and H5, the intro movies from computer games like Tekken and Rez, with interactive installations from UVA and Karsten Schmidt, architectural interventions from Jason Bruges Studio, live A/V performances from DJ Yoda to the Light Surgeons, comic character designers like Jamie Hewlett and James Jarvis, sharing the stage with record labels, Warp and NinjaTune to

anime feature premieres... a feast for eyes, ears and the creative mind, a new kind of festival. The programming format of the festival has developed to form four key strands: screening programmes, installations, live audiovisual performances and education, which gives plenty of scope to showcase, commission and demystify this idea of 'adventures in moving image' every year. Work is selected through annual open submissions, which is free to enter and encourages new talent, working artists and individuals from within creative industries to submit new work for festival curation.

onedotzero 藝術節於第一年起在倫敦當代美術館舉辦超過 10 年，之後持續擴大舉辦，從一開始的週末活動延長到為期兩週的視聽盛會。由於其規模已無法屈就於倫敦當代美術館，便於 2008 年重新定名為「onedotzero 動態藝術冒險盛會」，並改在英國電影協會南岸劇院舉辦，以便現今如此龐大的觀眾體得以參與。

藝術節每年在倫敦發表後，便轉往世界各地巡迴，將最令人振奮的新觀念和最具前途的影像製作新星介紹給各地觀眾，同時帶來世界頂尖創意人士的最新力作，進而將國際接軌。

onedotzero 藝術節一直保有宏觀的國際視野，其提供的視、聽覺冒險令喜愛它的非主流娛樂族群也在不斷的持續成長。其巡迴過的國際城市已橫跨半個地球，包括阿根廷的布宜諾斯艾利斯、中國的北京中華世紀壇數字藝術館、俄羅斯的聖彼得堡以及日本…等等。

Over a ten year residency at the Institute of Contemporary Arts in London, the onedotzero festival continually expanded, starting out as a long weekend and becoming a two-week audiovisual extraganza. Having outgrown the venue, the festival re-launched as "onedotzero_adventures in motion" in 2008 at it's new home BFI Southbank - the home of UK cinema to record breaking audience numbers.

Following the annual London premiere, the festival travels the world, showcasing the most exciting new ideas and brightest up-and-coming filmmaking talent alongside visionary new work by world-leading creative luminaries. As a result of this global reach, the onedotzero festival has always had an international perspective and a burgeoning audience hungry for visual adventure and alternative entertainment. Touring highlights have included Buenos Aires, CMODA, Beijing, St Petersburg and mini tours across Japan.

藝想城市
RE-IMAGINING THE CITY

根據歷史統計，全世界首次有超過一半以上的人口遷往並居住在城市裡，而目前在亞洲大約一個月就有 2 百萬人口搬移到城市居住，「藝想城市」計畫就是在這樣都會生活的重大變革背景下產生。onedotzero 與英國文化協會合作策畫為期 18 個月的「藝想城市」巡迴展，其著重於如何藉由扶植創意產業及其社群在城市中將都會再造，並遺留給下一代可貴的財富。

2006 年，英國文化協會邀請 onedotzero 策畫並發起有關於「創意城市」計畫的一連串活動，由英國與東亞諸國的文化界與藝術圈人士結盟，傾三年之力擘劃最具創造力的城市，以極富成就的知識經濟支撐下，為地球村村民灑下繁榮的沃土。

在持續不斷探索現代城市、現存環境，及探討藝術家在城市形象塑造中應扮演何種角色的基礎上，onedotzeroe 構思和發展了「藝想城市」這項計畫。這一系列的巡迴活動以設計師、音樂家、建築師和電影工作者等創意人士的角度去關注城市的未來。 這個計畫的核心是讓英國與東亞的藝術家合作，透過獨特且具活力的方式，用影像和聲音在各地區捕捉城市擴張的本質，同時也透過展示影片和深入探討將過程脈絡化。

該活動巡迴了東亞和太平洋地區 9 個國家中的 12 個城市，與超過 200 名創意人透過座談會、藝術進駐、影片放映、現場表演、媒體報導和訪談等形式相互合作。

In collaboration with the British Council, onedotzero curated and produced Re-Imagining the City, an 18 month touring project designed to highlight how nurturing creative industries and communities can lead to urban regeneration within cities, leaving a positive legacy for future generations. This was set against a backdrop of massive change in city living – for the first time in human history over 50% of the worlds population was now living in urban environments. It was estimated that two million people a month were moving to a city across Asia.

In 2006 the British Council approached onedotzero to create and curate a series of events as part of their creative cities programme, a three year cultural and artistic partnership between the East Asian region and the UK to develop creative cities with successful knowledge economies where global citizens can thrive.

Building on onedotzero's ongoing explorations into the contemporary city, the built environment, artists role in city shaping, onedotzero conceived and developed Re-Imagining the City. A touring series of events that focussed on our shared urban future through the eyes of creatives and artists: designers, musicians, architects, and filmmakers. The engine of the project was for British artists to collaborate with artists from East Asia in a series of activities to capture the essence of the urban expansion on film and in sound across the region in a unique and vital way whilst also contextualizing this with screenings, and discussions.

The tour reached nine countries and 12 cities across the East Asian and Pacific region, collaborating with an estimated 200 creatives on panel discussions, artist residencies, screening programmes, live shows and media coverage and interviews.

從 2007 年到 2008 年，由 onedotzero 選定的倫敦多媒體創意團隊 D-Fuse，與橫跨亞洲及大洋洲 11 個城市的在地製片人、設計師和音樂家進行交換計畫，嘗試將旁觀者的感知與在地人的知識結合，除了在技能與作法的交流之外，也發展和推動了泛區域網絡的形成。

此計畫的創意成果之一 -《浮光掠影》為一場多視窗現場影片表演，該作品由當地創作者和來訪藝術家的不同觀點，紀錄每一個巡迴城市，影片內容隨著每一站的巡迴而不斷發展，最後的版本「無限城市」曾在 2008 年 onedotzero 動態影像藝術節舉辦時於英國電影協會 IMAX 電影院播放，將整個活動的巡迴帶回終點站英國。

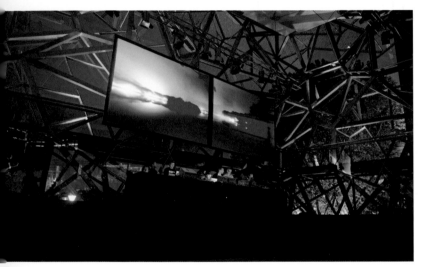

在經由包括一系列影音播映、小組探討、駐村交流研習；並同時鼓勵產業龍頭、學界人士及藝術家參與有關「藝術和設計如何影響並塑造城市」主題的辯論，進而塑造整個活動展演的基調和語境。

「藝想城市」是英國文化協會「創意城市」計畫中極重要的一環，由英國與東亞諸國的文化界與藝術圈人士結盟，傾三年之力擘劃最具創造力的城市，在成功的知識經濟支撐下，為地球村村民灑下繁榮的沃土。

onedotzero selected London-based multi-media creatives D-Fuse worked with local filmmakers, designers and musicians on exchange residencies in eleven cities across Asia and Australasia throughout 2007 and 2008. The idea was to attempt a combination of capturing the perspective of the outsider view with an insiders knowledge. An exchange of skills and methodologies were transferred and loyal and pan regional network was developed and encouraged.

One of the main outcome of these residencies and exchanged was 'Surface'; a multi-screen Live Cinema performance which documented each city through the eyes of the local and guest artists, evolving with each stage of the tour. A 'final' version renamed 'Endless Cities' was performed at the BFI London IMAX during onedotzero_adventures in motion in 2008 bringing it full circle back to the UK.

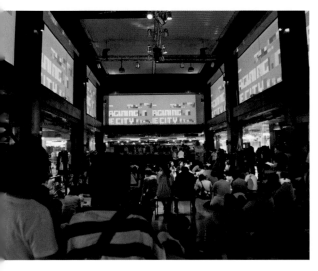

These live performances were contextualized through a series of screenings, panel discussions, residencies and workshops, encouraging industry leaders, academics, artists and members of the public to engage in the debate about how art and design can help to influence and shape cities.

Re-Imagining the City formed an integral part of the British Council's Creative Cities, a three-year cultural and artistic partnership between East Asia and the UK to develop creative cities with successful knowledge economies where global citizens can thrive.

「藝想城市」出版

「創意城市」計畫的成果出版將與香港 IdN
出版社合作，目前正在製作中。該書的內容
獨家揭露了這項泛太平洋巡迴活動產出的優
秀作品。此外，如城市復興、移民人口、創
意首都、城市與建築環境都市化之影響等，
和探索現代城市經驗主題的延伸議題也包含
在書中。而該書將以動態、攝影、平面設計、
文字和圖像等多種格式的精美套書形式呈
現。

「藝想城市」巡迴時間與地點

2007 年 12 月 17-18 日：紐西蘭 奧克蘭
2007 年 11 月 30 日 -12 月 2 日：南韓 首爾
2008 年 1 月 18-19 日：越南 河內
2008 年 1 月 21 日：越南 胡志明市
2008 年 1 月 25-28 日：泰國 清邁
2008 年 1 月 26-27 日：泰國 曼谷
2008 年 3 月 26-27 日：澳洲 墨爾本
2008 年 3 月 28-29 日：澳洲 布里斯班
2008 年 3 月 31 日 -4 月 6 日：馬來西亞 吉隆坡
2008 年 5 月 9-11 日：臺灣 高雄
2008 年 8 月 5-10 日：印尼 萬隆
2008 年 11 月 15 日：英國 倫敦

RE-IMAGINING THE CITY PUBLICATION

In production is a publication as a further project outcome of Re-Imagining the City in conjunction with IdN in Hong Kong. The book offers an unparalleled opportunity to present an array of stunning work generated from this pan-Asia Pacific tour. In addition extensions that support and explore the themes of the contemporary city experience, the impact of regeneration, migration flows, creative capital and urbanization of the city and the built environment are included. It will be presented across motion, photography, graphics, writing and imagery in a stunning multi-format volume.

RE-IMAGINING THE CITY TOURING DATES

17-18 October 2007: Auckland, New Zealand
30 November-2 December 2007: Seoul, South Korea
18-19 January 2008: Hanoi, Vietnam
21 January 2008: Ho Chi Minh City, Vietman
25-28 January 2008: Chiang Mai, Thailand
26-27 January 2008: Bangkok, Thailand
26-27 March 2008: Melbourne, Australia
28-29 March 2008: Brisbane, Australia
31 March - 6 April 2008: Kuala Lumpur, Malaysia
9-11 May 2008: Kaohsiung, Taiwan
5-10 August 2008: Bandung, Indonesia
15 November 2008: London, UK

AUCKLAND

For me the energy of Auckland's landscape and sea is the main creatively inspiring aspect of the city. It is a volcanic isthmus, with the harbours and ocean offering close proximity to the water in all directions. The volcanic forms are [in some cases] still strong visual markers in the city landscape. Their surface textures carry with them the stories of our layers of cultural history and living heritages.

Caroline Robinson, Auckland

BANDUNG

For me, Bandung is the city where tradition can blend with modernization in harmony. Maybe Bandung has been through multiple levels of evolution, but the value of tradition is still there in the heart of the city, in the people.

Puput Hidayat, Bandung

BANGKOK

The most creatively inspiring aspect of Bangkok is definitely the people. Bangkok is one of the most chaotic and unorganised cities in the world but the easygoing attitude [one of the most common phase for Thais is "mai pen rai" or "nevermind"] of its people makes the city unique and friendly.

Laila Bunnag, Bangkok

HANOI

Hanoi is very rich and diverse in culture and history. The street calls, the mixed architecture of the buildings, the old quarter streets which sell various handicraft items, the diversity of artforms, the friendliness of citizens – all become interesting and inspiring factors of our city.

Ha Thien Ha, Hanoi

KUALA LUMPUR

Everyone's got a point of view about the city, whether it's the city you live in or one you visit as an outsider. Trying to capture that in any form, whether verbal, visual or otherwise, is profoundly challenging.

Sunitha Janamohanan & Patriana Patrick, Kuala Lumpur

MELBOURNE

With the internet bringing the whole world closer we all feel a little less isolated in Australia now.

Ajax McKerral, Melbourne

SEOUL

Seoul is a megacity without a core and centred image, comparable to a teenager whose body has grown but is yet to mature.

Jeon Yongseok, Seoul

案例介紹 - 教育活動

CASE STUDY - EDUCATION

onedotzero_CASCADE

Cascade 是一個具有擴展性與彈性張力的創意體驗教育模式，這項計畫旨在促進來自不同創意學科的年輕力量，如整合在學人才和在職人士之間的合作，或嘗試體驗跨學科工作和新科技帶來的創意機會。

教育合作夥伴

該課程與來自文化界和創意產業中的佼佼者合作，包括建築、室內設計、動畫、平面、互動設計和插畫領域等先驅，為參與者提供啟發、洞見、實踐指導和實際體驗，並使學員們親身在短短的 5-7 天內，經歷且發展出跨領域的專案，這樣獨特而俱多樣性的工作關係，有助於促進日後年輕創意人才間的合作。

Cascade 為創意領域的跨界合作開發一種新的模式，其同時為有志於在創意領域發展的個人，培育其專業能力。它挑戰傳統的課程模式和格局，鼓勵創新、探索與參與，促進合作並發展出更新、更刺激的創意思考和工作模式。

The cascade programme aims to promote collaboration and convergence amongst young people, students and graduates from different creative disciplines to test and respond to the creative opportunities offered by cross-disciplinary working and new technologies. Cascade is a scalable, flexible model of creative experiential education.

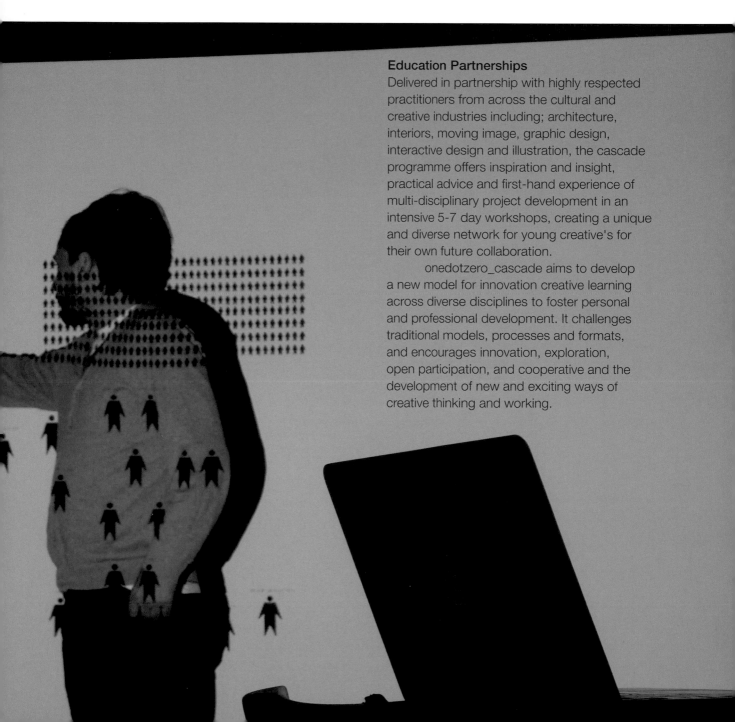

Education Partnerships
Delivered in partnership with highly respected practitioners from across the cultural and creative industries including; architecture, interiors, moving image, graphic design, interactive design and illustration, the cascade programme offers inspiration and insight, practical advice and first-hand experience of multi-disciplinary project development in an intensive 5-7 day workshops, creating a unique and diverse network for young creative's for their own future collaboration.

onedotzero_cascade aims to develop a new model for innovation creative learning across diverse disciplines to foster personal and professional development. It challenges traditional models, processes and formats, and encourages innovation, exploration, open participation, and cooperative and the development of new and exciting ways of creative thinking and working.

onedotzero_CASCADE 2008

第一屆 Cascade 是由 onedotzero 的專案主管
Sophie Walter 在 2008 年策劃的，吸引了來
自不同大專院校、不同創意相關學科背景、
不同年齡層的學生參與。該屆活動要求參加
學員以重新思考我們居住的城市與環境，以
及倫敦這個城市如何能被他們自己所提出的
企劃影響。

onedotzero 總監 Shane Walter 透過對於「藝想
城市」和 Jason Bruges 工作室介紹等主題來
進行演講和研討，進而啟發學員們的思維。
學員們被分成小組集體創作。本屆活動吸引
了來自 10 個不同創意相關學科背景、不同年
齡層的 80 名學生參與共 8 天的活動，並且
有 11 位業界專業人士和 2 組拍攝人員參與。
最終，在 2008 年 11 月於英國電影協會南岸
劇院舉辦了一整天的活動、辯論和討論。該
活動同時也作為 onedotzero 動態影像藝術節
的一部分。

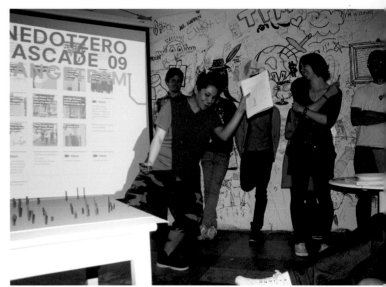

onedotzero_CASCADE 2009

2009 年第二屆 onedotzero_cascade 在位於
倫敦巴特希的設計公司 Squint Opera 的藝術
空間內舉辦，共有來自 17 個不同創意學科
的 40 位畢業生參與。在六天的活動中，學
員由 9 位來自當紅數位設計公司的專業人
士和藝術家們所指導，包括如 Greyworld、
Quayola、Squint Opera、Moving Brands 和
Arduino 等 。學員們在每天上午進行創意發
表，並在下午與組員將他們的概念進一步的
發展，同時在各組的部落格上紀錄全部過程。
該屆活動在 2009 年 9 月的 onedotzero 動態
影像藝術節，於英國電影協會南岸劇院舉辦
一整天的辯論和討論。

onedotzero_CASCADE 2008

The very first cascade developed by
onedotzero with project lead, Sophie Walter.
In 2008 over 8 days, students from a variety
of creative disciplines, different universities,
colleges, schools and ages took part in the
first onedotzero_cascade. The brief asked the
participants to be inspired by and respond
with a concept that rethinks our city and the
environment we inhabit, how we could be
positively affected by their proposed work in
cities – particularly London. Their work took
inspiration from presentations and workshops
by Shane Walter of onedotzero talking about
Re-imagining the City and Jason Bruges
Studio. Teams were formed to collaborate and
create together. The result was 8 days, with
80 students, across 10 disciplines, with 11
professional practitioners, two film crews and
lots of mucky plaster. This concluded with a day
of activity, debawte and discussions at the BFI
Southbank, London in November 2008 as part of
onedotzero_adventures in motion festival.

onedotzero_CASCADE 2009

In 2009, 40 graduates from 17 different disciplines took part
in the second onedotzero_cascade at design company
Squint Opera's Doodle B space in Battersea, SW London.
Over six days, the students where joined by nine professional
practitioners from leading digital organisations and artists
such as Greyworld, Quayola, Squint Opera, Moving Brands
and Arduino. They presented inspirational talks in the
morning and worked with the groups in the afternoon to
develop their concepts. Each group documented the whole
process via their own team blogs. The project concluded with
a presentation day of debate and discussion at onedotzero_
adventures in motion festival at the BFI Southbank, London in
September 2009.

onedotzero_CASCADE 2010

2010 年第三屆 onedotzero_cascade 也邀請 40 位畢業生參與。而來自 16 個不同創意學科的優秀畢業生被分為四個跨學科小組。學員由 kin design、自由工作者 John Nussey、演員 Darren Hart 和 Sharona Sassoon 等業界專業人士指導，他們帶領學員間的研討、鼓勵團體合作、培養他們的簡報技巧，並協助學員們延伸思考和增加「軟實力」。

持續一周的研討會在最後階段由每一組發表他們的最終提案，由如選秀節目陣容般的業界人士，包括 Kin design、Hellicar + Lewis、AllofUs 和 onedotzero 等藝術家擔任評審。在過程中，每一組學員也將他們的思想、靈感、構思和進展記錄在部落格上。最終，他們的作品在 2010 年 11 月舉辦的 onedotzero 動態影像藝術節中，於英國電影協會南岸劇院對觀眾、創意產業和學術界發表。

onedotzero_CASCADE 2011

在 2011 年的活動中，由來自於 16 個不同創意學科中的 40 個創意新鮮人參與了 onedotzero 發起的五日研討會，並由時下最前衛的藝術家們包括 Kin design、Mother、the Spring Project 和 Guardian Digital 帶領，以小組形式，針對 onedotzero 總監 Shane Walter 所出的「層級城市的深度生活」題目中作創意發想，探索當下真實與虛擬世界之間的模糊現況。在行動科技越趨發達的時代，「甚麼造就了我們的城市」在 21 世紀是一個很重要的課題。這個活動強調透過彼此互相激發創意、接收新的看法、學習新的技巧和新的設計語彙，去成功的塑造和支撐一個強烈的概念。

整個活動的高潮在總研討會，邀請到包括業界從業人員、創意產業領袖人物、教育工作者等各界人士，和學生們作面對面的交流，並由設計界的專欄作家暨設計類網站 Design Week 的前任編輯 Lynda Relph-Knight 擔任主席，同時由設計界的超級巨星 Wayne Hemmingway 擔任專題講者。

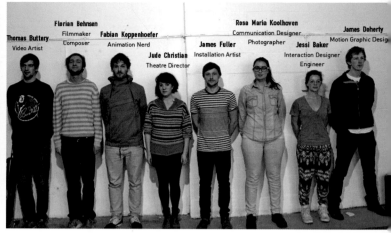

Thomas Buttery
Video Artist

Florian Behnsen
Filmmaker
Composer

Fabian Koppenhoefer
Animation Nerd

Jude Christian
Theatre Director

James Fuller
Installation Artist

Rosa Maria Koolhoven
Communication Designer
Photographer

Jessi Baker
Interaction Designer
Engineer

James Doherty
Motion Graphic Desig

onedotzero_CASCADE 2010

40 graduates took part in the third onedotzero_
cascade 2010. The high calibre graduates
from 16 different creative disciplines split into
four multi-disciplinary teams. The teams were
joined by professional practitioners Kin Design,
freelancer creative technologist John Nussey
who led workshops to encourage collaborative
ways of working, develop presentation skills
with actors Darren Hart and Sharona Sassoon,
and support the groups in developing their
ideas and 'soft skills'.

 The week long workshop ended with
each group presenting their final concept to
a talent show style [think X-Factor] industry
panel that included Kin Design, Hellicar &
Lewis, AllofUs and onedotzero. Each team
documented their thoughts, inspirations, ideas
and progress on their own team blogs. The
groups presented their final ideas at the BFI
Southbank, London to an audience of peers,
creative industry and academia during the
onedotzero_adventures in motion festival, in
November 2010.

onedotzero_CASCADE 2011

In 2011, 40 creative graduates participated
in the five day workshop led by some of
onedotzero's most innovative partners, creators
and featured artists: Kin design, Mother, the
Spring Project and Guardian Digital. The diverse
graduates represented 16 creative disciplines.
Working in small multi-disciplinary teams they
tackled a brief set by onedotzero's director
Shane Walter that explored the theme of 'living
in the layered city' as physical and virtual
worlds increasingly intertwine. With new mobile
technologies underpinned by an increasingly
connected environment we are it is an important
time to question what makes a city in the 21st
century. The emphasis is on drawing inspiration,
gaining new perspectives and learning new
skills and design languages from each other to
successfully form and champion one single and
strong idea.

To coincide with the culmination of cascade
in 2011 a one day conference was mounted
bringing in practitioners, creative industry
leaders, eduators and students, chaired by
leading design writer and ex editor of Design
Week, Lynda Relph-Knight and a key note by
Design superstar Wayne Hemmingway.

案例介紹 - 專案創作

CASE STUDY - PROJECTS

作品：

WIND TO LIGHT

Wind to Light 是由 onedotzero 和 Light Lab 委託 Jason Bruges 工作室為 2007 英國建築周所創作。2007 英國建築周是由英國藝術協會、英國皇家建築師協會和建築中心聯絡網共同舉辦，聚焦於生態及資源永續等議題上，並丟出一個值得反思的問題：「我們的空間環保嗎？」企圖啟發人們對於居住空間和周遭環境進行創造性的思考。

Wind to Light 是一個專為特定地點量身打造的裝置，利用 500 個小風力發電機直接提供能源讓幾百個 LED 燈所組成的燈光組運作。LED 燈和風力發電機安裝在一根有彈性的的杆子上，它們可以隨風搖曳，而當幾百個 LED 燈出現在城市的夜晚時，彷彿一大群螢火蟲漫天飛舞，形成一朵流動的電子雲，將風以數位、電子的方式，視覺化地表現出來。這個自行發電的獨立裝置說明了風力的簡單、直接，以及它的潛力；不論就事實或象徵而言，消弭了發電和消費之間的鴻溝。Wind to light 在視覺上將風力以有形的方式表現，並以其引發的結果而非過程為著重點，有力的表現出風的無聲力量。

Jason Bruges 工作室的創作作品十分多元，包括互動照明雕塑、互動環境、活動及影像裝置。該工作室致力於透過創意運用極富於想像力及創新的技術，探索交互性的應用和探索個體與環境之間的關係。

Wind to Light 展現了另一種觀察角度，即風力可以是迷人的，甚至有增添景觀美感的潛力。與之相反的，許多廣泛的意見認為人造的風力發電設備在視覺和實質上，都破壞了景觀的自然風貌。如此將風力發電從鄉村移置到城市，不但實際將它帶入與我們息息相關的生活中，也顯示出隨著我們對於風力的需求日益增加，對於它的運用和設置地點的看法也應該跟著進步。或許與其在鄉下，風力發電機更適合與它關係密切，且更需要它的城市環境中。

作者 Jason Bruges 說：「Wind to Light 是一個探索風能的可能性的實驗性作品。我希望它除了能引起人們的思考，同時也可以是一件被各個年齡層所欣賞的藝術創作。」

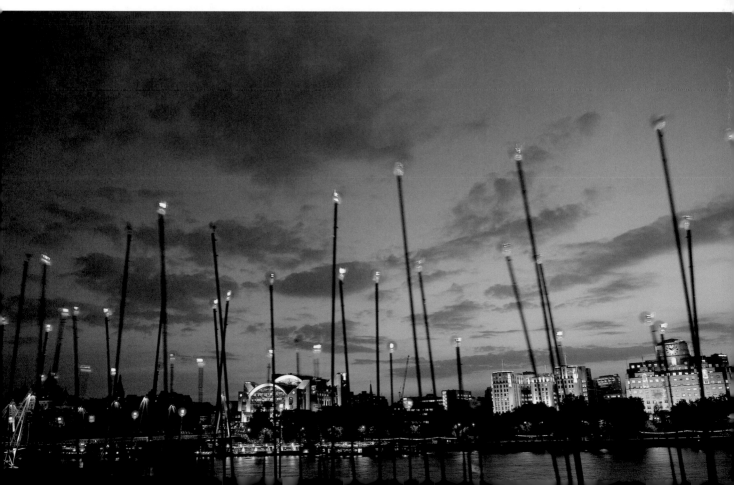

PROJECT:
WIND TO LIGHT BY JASON BRUGES STUDIO

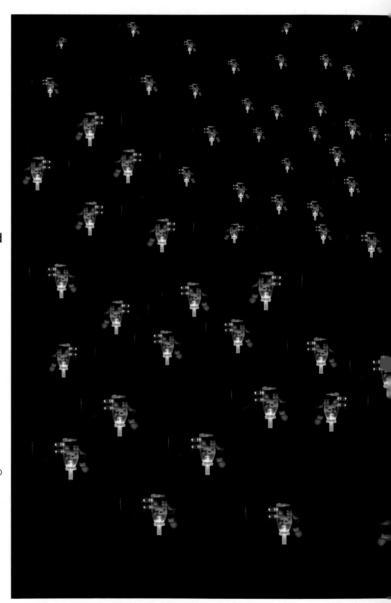

Wind to Light is a project commissioned by onedotzero and Light Lab for Architecture Week 2007 in the UK, executed by Jason Bruges Studio. The events for the year's architectural celebration, organised by the Arts Council England, RIBA and the Architecture Centre Network, were focused upon issues of ecology and sustainability posing the reflective question 'how green is our space?'. Its aim was to inspire people to think creatively about the spaces that surround them and which they inhabit.

Wind to Light was a custom built, site-specific installation consisting of 500 miniature wind turbines directly harnessing and generating the power to illuminate hundreds of integrally mounted LEDs (light-emitting diodes). The effect was to create 'firefly-like fields of light' where the wind can be visualized as an ephemeral electronic cloud in the atmosphere. The turbine and LED modules are attached to their base by flexible poles, which allow them to slightly sway in the wind, animating the movement of the wind by a digital, electronic means.

The self-powered, autonomous installation illustrates the simplicity and directness of wind power and its potential, literally and symbolically closing the gap between power generation and consumption. Wind to light presents wind power in a visually tangible way and one that is characterised primarily by its resultant output rather than process. It eloquently illustrates the silent power of wind.

Jason Bruges Studio produces a wide range of diverse work including interactive light sculptures, interactive environments, events and screen based

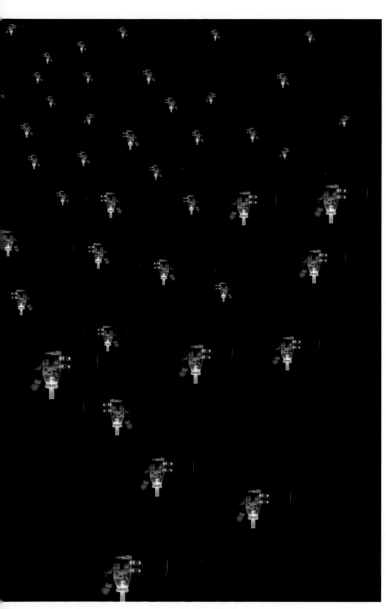

installations. Their objective is to explore the applications of interactivity and the relationship between individuals and their environment through the creative use of highly imaginative and innovative technologies.

Wind to Light presents the perspective that wind power can be an attractive or even potentially beautiful addition to the landscape, contrary to many widespread opinions that wind turbines are a man-made, visual and physical intrusion upon scenery and its natural beauty.

The relocation of wind power from the rural environment to urban surroundings literally brings it closer to us and suggests that as our requirements from wind power have evolved since the use of windmills so should our attitudes towards its application and location. Perhaps wind turbines are more suited within the man made environment than nature where they are alien and their need is divorced from them.

Jason Bruges says: "Wind to Light' is an experimental piece, an investigation into the viability of wind power. I hope it will prove thought-provoking as well as being an art piece that can be enjoyed by people of all ages".

作品：

TRIPTYCH

UVA 的作品 Triptych 是為 onedotzero 在 2007 年巴黎白夜藝術節舉辦的活動所創作，並曾在荷蘭今日藝術節中展出，至今也不斷在世界各地許多城市中巡迴展示。這個視聽裝置由三面相同大小、裝有動態感應攝影機的 LED 牆組成。它仰賴周圍觀眾與它的互動而發出光和聲響（由 Mathias Kispert 創作）。

當感應到有人靠近，它原本發出的柔和顏色和舒緩聲響會轉變為銳利和喧囂，意味著 Triptych 有著喜怒無常、強而有力的內在個性。它不但成為一個可演奏的大型樂器，也是一個將新科技與舊有建築構成強烈對比的巨大城市公共藝術，同時也為城市的景觀及空間增添光彩。

Triptych 是由 onedotzero 2006 年的為委託創作作品 Monolith 發展而來的，該作品是為 onedotzero 在倫敦維多利亞與亞伯特博物館策展的 Transvision 周末夜而作。本作品由 onedotzero 委託創作。

PROJECT
TRIPTYCH

UVA work Triptych is onedotzero in 2007 Paris Nuit Blanche festival events is the author, and worked in the Netherlands Art Festival held today, has also been in many cities around the world touring show. This device consists of three sides audiovisual same size, the camera is equipped with motion sensor LED wall components. It depends on its interaction with the surrounding audience light and sound issued (by the Mathias Kispert creation).

It will not only become a major instrument can play, but also a new technology and the old building sharp contrast to the huge urban public art, but also for the city's landscape and space to add luster.

Triptych by onedotzero 2006 years of commissioned works Monolith evolved, the work is onedotzero Victoria and Albert Museum in London, curated Transvision night and weekend work. This work commissioned by the onedotzero.

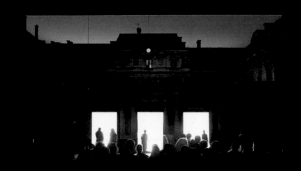

作者介紹

UNITED VISUAL ARTISTS

來自英國倫敦的藝術設計團隊 United Visual Artists(UVA) 成立於 2003 年。其作品包括雕塑、建築、現場表演、動態影像和數位裝置藝術等。

UVA 的成員來自美術、建築、視覺傳達設計、動態影像、資訊工程等各個不同專業背景。這樣的跨界合作使他們可以不斷探索新的領域，也成為他們的核心精神，並大膽挑戰每個案子的研究、軟體和工程的極限。UVA 認為創作最重要的是必須深具意義，而且能打動人心。

他們的藝術作品曾在英國維多利亞與亞伯特博物館、皇家藝術學院、南岸中心、威爾康醫學博物館、里茲北方大歌劇院、德倫教堂、大英圖書館中展出；並曾到許多國際城市巡迴展覽，包括巴黎、紐約、洛杉磯、東京、福岡、臺北、香港、墨爾本和巴塞隆納。另外，UVA 也在多倫多和伊斯坦堡擁有大型的常設作品展。

ARTIST PROFILE
UNITED VISUAL ARTISTS

Established in 2003, United Visual Artists are an art and design practice based in London. UVA produce work at the intersection of sculpture, architecture, live performance, moving image and digital installation.

UVA's team members come from many disciplines including fine art, architecture, communication design, moving image, computer science and engineering. The cross-pollination of diverse skills inspires new fields of exploration, which is core to their ethos. Pushing the boundaries of research, software and engineering with every project, UVA's work aims above all to be meaningful and engaging.

UVA's work has been exhibited at institutions including the V&A, the Royal Academy of Art, the South Bank Centre, the Wellcome Collection, Opera North Leeds, Durham Cathedral and The British Library. Their artworks have also toured internationally to cities including Paris, New York, Los Angeles, Tokyo, Yamaguchi, Taipei, Hong Kong, Melbourne and Barcelona. UVA also have large scale permanent art works in Toronto and Istanbul.

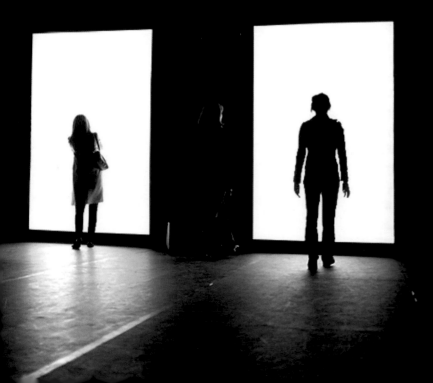

此外，包括泰德現代美術館渦輪機廳、紐約麥迪遜花
園廣場、倫敦特拉法加廣場等都曾委託 UVA 創作現
場演出的作品。UVA 更曾與強烈衝擊、Jay Z、U2、
化學兄弟、Battles 等音樂人合作。由 onedotzero 委
託他們創作的現場視聽作品也曾隨藝術節在倫敦、
臺北、新加坡、布宜諾斯艾利斯和東京等地演出。

UVA 頗受好評的聲光雕塑作品 Volume 在 2007 年獲
頒 D&AD 黃鉛筆獎，並在 2008 年倫敦設計博物館舉

UVA's designs for live performance
have led to commissions at venues
such as the Tate Modern turbine hall,
Madison Square Garden in New York
and Trafalgar Square London. UVA
have also collaborated with musicians
including Massive Attack, Jay Z, U2,
Chemical Brothers and Battles. They
have performed their own live A/V
show commissioned by onedotzero
that toured with the festival to London,

作品
FEEDBACK

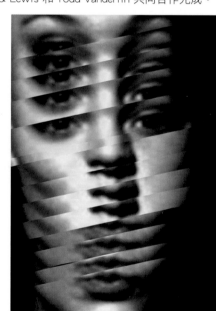

Feedback 是個讓一般觀眾能輕易做出如馬戲團表演般效果的互動裝置。這件作品是為了 2010 年在倫敦 Roundhouse 舉辦的馬戲盛會而創作，並首次在該活動中展出。

其以人們熟悉的鏡子作為呈現型態，這個裝置使用即時同步的電腦視覺技術，並攜其程式碼和 openFrameworks，讓民眾的身體在畫面中即時被重組，並將效果展示於倫敦 Roundhouse 的內部和外牆，由 Hellicar & Lewis 和 Todd Vanderlin 共同合作完成。

鏡子也許是我們認為最平易近人的媒介，它讓人們容易融入表演中，進而成為整個藝術節的一部分。無論是在螢幕前的舞蹈、表演或覷腆的手勢，這個裝置會將人們與它互動中的所有動作創造成動畫圖像。效果如同「鏡廳」一樣，讓反映出的影像產生一種無法預期的、魔法般的晃動、扭曲和延展。

這件作品也在之後的 2010 年，於倫敦英國電影協會舉辦的 onedotzero 動態影像藝術節 、加拿大 Banff 藝術中心、onedotzero 在聖彼得堡策展的 Yota Space 國際視聽藝術節以及其他許多活動中展出。

Feedback 由 Roundhouse 和 onedotzero 委託創作
策展人 / 製作人：Shane RJ Walter
製作人：Claire Spencer Cook

PROJECT
FEEDBACK BY HELLICAR & LEWIS

Feedback is an interactive installation that aims to encourage new performances out of members of the public and circus performers alike. It was originally created for and premiered at CircusFest at the Roundhouse, London in 2010.

Using the familiar form of a mirror, the installation uses real time computer vision techniques using custom code and openFrameworks. It allow viewers to remix their bodies in real time, displaying them on a large scale over the interior and exterior of the iconic roundhouse in Camden, London. It was Made in collaboration with Todd Vanderlin.

The mirror, which is probably the most natural interface we know, makes it easy for people to get involved in the acts of performance, thus becoming part of the festival itself.

vBy dancing, performing – or even modestly gesturing in front of the screen – the installation will capture the movement of anyone interacting with it to create a graphic animation of their body movements. The effect is similar to that of a 'Hall of Mirrors', generating an unexpected and magical wobbly, bendy or stretched reflection.

It has since been exhibited at onedotzero_ adventures in motion at the BFI London in 2010, the Banff Art Centre in Canada, in St. Petersburg as part of the onedotzero curated Yota Space as well as numerous other events.

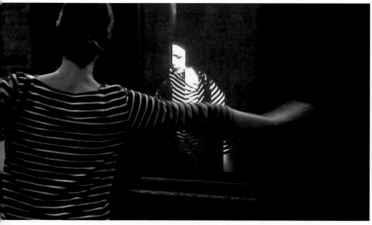

Feedback was commissioned by the Roundhouse and onedotzero
Curator/ Producer: Shane RJ Walter
Producer: Claire Spencer Cook

HELLICAR & LEWIS

Hellicar & Lewis 是 由 Pete Hellicar 和 Joel Gethin Lewis 組成的藝術團隊,他們運用藝術、科技和設計,創造出能夠成為觀眾永恆記憶的新體驗。

近來,他們曾為可口可樂策畫連續 24 小時的全球音樂活動。這個計畫將全球樂迷在社群網絡上的即時發文納入創作的一部分,並投影出來,同時讓現場觀眾用 Twitter 參與對話。

Lewis 主修互動設計,2003 年由皇家藝術學院畢業後,加入班尼頓集團傳播研究中心 Fabrica 擔任互動設計師,並曾和 U2、Massive Attack 等樂團一起工作和巡迴表演。Lewis 在 2007 年開始使用 openFrameworks 為互動藝術創作工具後,隔年才於與 Hellicar 成立現在的公司,該公司的明確目標就是建立起一個使用開放式原始碼的創意事業。

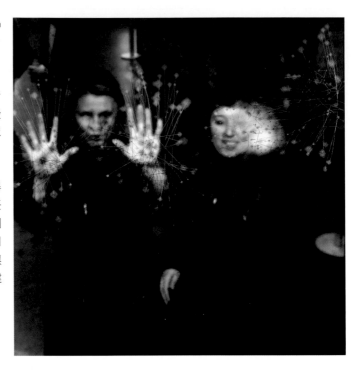

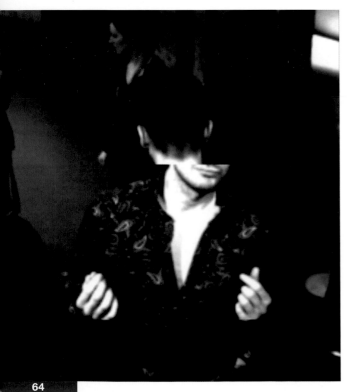

其搭檔 Hellicar 曾是一名巡迴世界的職業滑板運動員,後來在 1997 年創立 Unabomber Skateboards 滑板設計公司,生產包括 Pete Fowler 和 Will Sweeney 等設計師所設計的滑板和相關服飾。Hellicar 在 2001 年成為 Etnies Worldwide 的藝術總監,主要負責重新包裝滑板名牌 Etnies 的廣告形象,也包含商標和服裝的設計。2004 年他返回英國,繼續為 Etnies 指導藝術活動,並為 Channel 4、Topshop、Orange 等品牌擔任設計顧問。

Lewis 倡導並推廣使用開放式原始碼和大眾程式設計教育,此外,他還創立了國際互動設計交流會「創意成真(This Happened)」等,同時也是 Enlightenment Club 的創始人。

除了商業作品外,Hellicar & Lewis 也熱愛關於教育、藝術以及表演領域的工作。他們目前正參與一項治療自閉症青少年的互動式軟體開發。

ARTIST PROFILE
HELLICAR & LEWIS

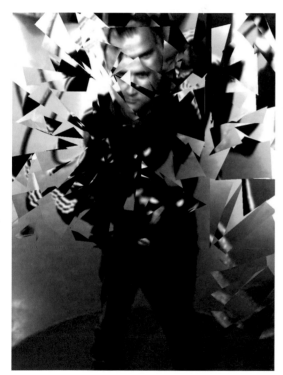

Hellicar & Lewis is the partnership between Pete Hellicar and Joel Gethin Lewis. Their work uses art, technology and design to create groundbreaking experiences that take people into the moment to impart lasting memories.

Recently, the duo worked on a global 24 Hour Music event for Coca-Cola. The project involved taking real-time input from music fans across the globe from social networks and projecting it, while also allowing visitors to contribute to the conversation via Twitter.

Lewis completed an MA in Interaction Design at the Royal College of Art in 2003. Post-graduation he worked at Benetton's communication research centre, Fabrica, before returning to London where he worked as an interaction designer with United Visual Artists. Here he collaborated and toured with the likes of U2 and Massive Attack.

After discovering OpenFrameworks in 2007, Lewis co-founded Hellicar & Lewis in 2008 with Hellicar. The business was founded with the express aim of building a creative business around Open Source.

Hellicar toured the world, skating professionally, before co-founding Unabomber Skateboards in 1997. Here he produced boards and apparel featuring the work of, among others, Pete Fowler and Will Sweeney.

In 2001 Hellicar became the art director for Etnies Worldwide, where he was responsible for the rebranding of Etnies advertising, including all logos and apparel. In 2004 he returned to the UK, where continued art directing campaigns for Etnies and doing design consultancy for clients like Channel 4, Topshop and Orange.

Lewis is an advocate of the Open Source approach throughout society, in addition to the need for a programming education for all. He co-founded the international interaction design meet-up, This happened…He is also the founder of The Enlightenment Club.

In addition to their commercial work, Hellicar & Lewis also enjoy working in educational, artistic and performance contexts. The creative duo are involved in an ongoing project that creating interactive therapeutic software for young people on the Autistic Spectrum.

Topologies 是藝術家 Quayola 的 Strata 系列作品中的一件藝術裝置。與之前 Strata 系列的其他藝術作品不同的是，Topologies 不是在描述一個變化的過程，而是將焦點放在觀察轉變完成後的對象上。用以作為觀察對象的是普拉多美術館的兩幅指標性收藏：西班牙畫家委拉斯開茲的〈宮女〉和義大利畫家提也波羅的〈聖母懷孕〉。

作者順著原作視覺構圖和顏色使用的規律，運用一套特定軟體把這兩幅巨作變成數位形態構造。Topologies 主要是探索經由這個轉變過程創造出來的數位物件。他希望讓觀眾對所生成的影音主題去發生冥想，而不是去生成一個敘事的劇情片，他說「我最終的目的並不是談論制作電影，這些不是電影，他們是有著一定規模的思考模式，是一種比例，也是人與空間的對話。」。

Topologies 重新喚起隱藏在近代經典名作細節背後一些生命無規律性的趣味，像是生物體轉換成某種其他色彩飽和的實體，或是設計精良的虛構物。這些幾何圖像變成地質的圖、線條和結構，彷彿有脈搏般，擺脱了原始，成為一幅有生命力的抽象景觀。

Quayola 是 onedotzero 經常合作的一位藝術家。Topologies 這件作品在 2010 年 onedotzero 動態影像藝術節中，於英國電影協會以多螢幕裝置形式首次展出。
該作品由 onedotzero 和英國電影協會委託創作，與英國電影協會藝廊合作。

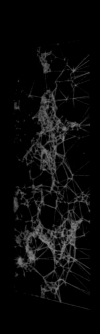
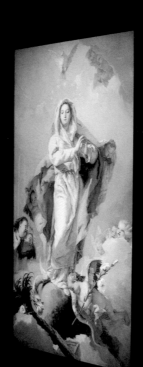

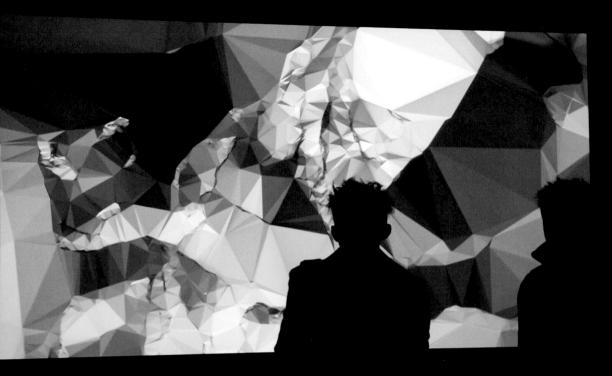

PROJECT
TOPOLOGIES BY QUAYOLA

Topologies is an installment of the artist Quayola's Strata Series. In differentiation to the previous Strata pieces, Topologies does not describe a process of transformation, rather it focuses into the observation of objects that are already fully transformed. The subjects of these new pieces are two iconic paintings from the Prado Museum's collection: 'Las Meninas' by Velazquez and 'L' Immacolata Concezione' by Tiepolo.

Following the rules behind their visual composition and colours, the two masterpieces have been transformed into digital fabrications through the use of custom software. Topologies consist in the exploration of the digital objects created by this transformation process. The outcome is not a narrative film but rather separate objects of contemplation... literally "digital paintings". Topologies renews an interest in the calculative, generative and arrhythmic qualities that lie dormant behind the details of a masterpiece, organically transforming a recognisable reality into a colour-saturated, calculated fabrication. These paintings become topographic maps, linear pathways and structures, which pulsate, diverging from the original to produce a living abstract landscape.

Quayola, a onedotzero regular contributor and artist premiered Topologies in a multi-screen installation at the onedotzero_adventures in motion festival in 2010 at the BFI Southbank London in 2010.

Commissioned by onedotzero In collaboration with BFI Gallery, London

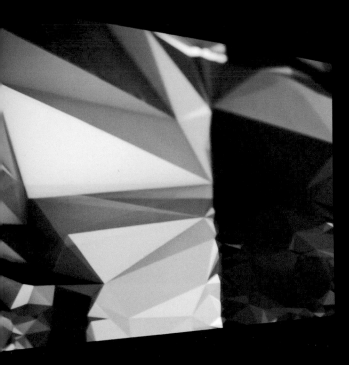

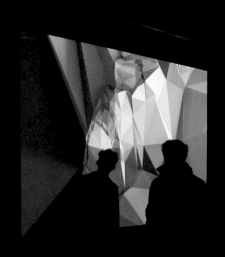

作者介紹
QUAYOLA

倫敦藝術家 Quayola 的視覺藝術主要於探究自然與人造、具象與抽象,以及新與舊之間其矛盾的衝擊、張力與平衡。他的作品探索攝影、幾何學、以時間為基礎的數位雕塑,做出極具吸引力的視聽裝置與表演。

Quayola 的作品曾在威尼斯雙年展、倫敦維多利亞與亞伯特博物館、倫敦英國電影協會、紐約公園大道兵工廠、巴黎抒情愜意中心、巴黎電影影像中心、波爾多大劇院、法國里爾美術宮、巴西聖保羅影音博物館、米蘭三年中心、巴塞隆納電音節、加拿大 ELEKTRA 國際數位藝術節和法國克萊蒙費宏影展中展出。

其獲邀在 onedotzero 的世界巡迴展、藝術節和在北京中華世紀壇數字藝術館、聖彼得堡 YotaSpace、布宜諾斯艾利斯等地舉辦的展覽活動中展示。

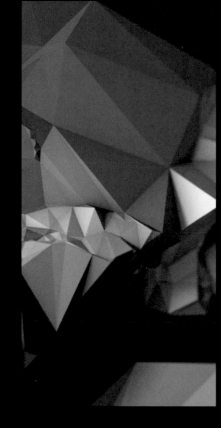

Quayola is a visual artist based in London. He investigates dialogues and the unpredictable collisions, tensions and equilibriums between the real and artificial, the figurative and abstract, the old and new. His work explores photography, geometry, time-based digital sculptures and immersive audiovisual installations and performances.

Quayola's work has been exhibited at the Venice Biennale; Victoria & Albert Museum, London; British Film Institute, London; Park Ave Armory, New York; La Gaite Lyrique, Paris; Forum des Images, Paris; Grand Theatre, Bordeaux; Palais des Beaux Arts, Lille; MIS, Sao Paulo; Triennale, Milan; Sonar Festival, Barcelona; Elekra Festival, Montreal and Clermont Ferrand Film Festival.

His work has been shown as part of onedotzero's worldwide touring, festival and exhibition programme including CMODA Beijing, YotaSpace St Petersburg, and

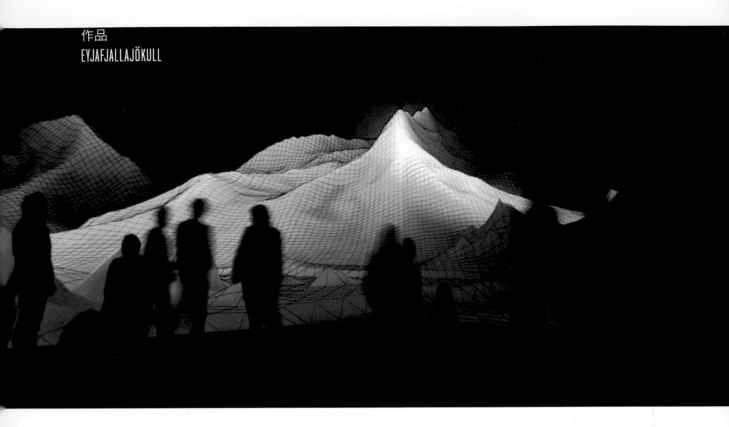

Joanie Lemercier 的視聽繪圖作品 Eyjafjallajökull，創作靈感來源於 2010 年 4 月噴發而癱瘓整個歐洲領空的冰島火山。

此次他嘗試了新的實物投影技術，在強調極簡美學和視錯覺之下，創造出平面物體不可思議的深度感。其將畫在巨大牆面的山景以多個光源投射，刻劃出如虛擬世界般簡潔、壯麗，且具未來感的寫實山群景觀，同時還能表現出生機和自然。

Joanie 多年來著迷於幾何學和極簡主義，他的大部分作品都十分簡潔、冰冷，並且較為抽象而少有具象或寫實的元素。他便想開始去使用更多有機型態，增加曲線而減少稜角。因深受數學、幾何學和自然之間的密切關係所吸引，他希望在作品中探索這層關係，並融入一些可以連結幾何圖形和海浪、地形、山峰地貌、風、雪和雨的動態的視覺元素。

作品的概念是將一層燈光投射在作者畫出的圖上，製造出視覺上深淺的效果，並以色彩及光影等的動態變化，將靜止不動的火山生動的表現出來。觀眾的感知也隨著視錯覺而產生對空間的質疑，其認知逐漸被挑戰。以一波波的光線照過線框描繪出的土壤和火山作為這件作品的結尾，Joanie 形容這有點太過抽象和太具未來感。這也許是在創作的當下，他一邊聽著火山噴發的田野錄音，一邊又在聆聽 Robert Henke（Monolake 樂團）的專輯有關。

這件作品創作於 onedotzero 2010 年 4 月於美國實驗媒體與表演藝術中心駐村時期，並在 2010 年倫敦 onedotzero 動態影像藝術節和 2011 年北京中華世紀壇數字藝術館和世界各地許多城市展出。

本作品由 onedotzero 委託創作。

PROJECT
EYJAFJALLAJÖKULL BY JOANIE LEMERCIER'S (ANTIVJ)

Joanie Lemercier's (AntiVJ) audiovisual mapping project, Eyjafjallajökull, was inspired by the Icelandic volcano, which wreaked travel havoc across Europe in April 2010.

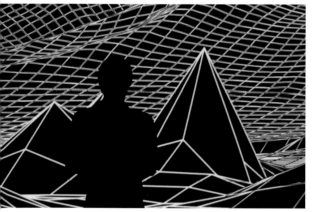

Joanie takes a new approach to his projection mapping technique focusing on minimal aesthetics and optical illusion to give an uncanny sense of depth to flat surfaces. Projecting sources of light over a scenery painted on large walls, he creates a sense of realism in an imagined landscape of Tron-like clinical and futuristic mountains that also offers and organic and natural wonder.

Joanie has been obsessed by geometry and minimalism for years, and most of his work has been very clinical, cold, and more abstract than figurative or realistic, and he wanted to start working with more organic shapes, and start using curves, less angular patterns. Being fascinated by the relationship between maths, geometry and nature, he wanted to explore that idea in his work, and incorporate some visual elements that would connect geometric patterns and ocean waves, terrain, mountains relief, wind, snow and rain motion.

The concept was to project a layer of light onto the painted visual, and use this "virtual layer" to create depth effects and enhance the visual by adding colours, animations and motion to the still graffiti like painting. The audience's senses are progressively challenged as optical illusions question their perception of space.

Joanie describes the end of the piece as a bit more abstract and futuristic, with waves of light going through the wireframe soil and the volcano. He worked with field recordings of the eruption, and a beautiful track from Robert Henke [Monolake].

This project was initially developed during the onedotzero residecy at EMPAC in the USA in April 2010 and has since been presented at onedotzero_adventures in motion in London 2010 and at CMODA in Beijing in 2011 as well as numerous other places worldwide.

Commissioned by onedotzero

作者介紹
ANTIVJ - JOANIE LEMERCIER

Joanie Lemercier 是視覺藝術品牌 AntiVJ 的經營者，
該品牌初期是由一群歐洲視覺藝術家促成，他們的
作品關注於投射燈的運用和如何將它影響人們的感
官。

不依循標準的規定和技術，AntiVJ 呈現的現場表演
和裝置皆帶給觀眾感官的挑戰以及驚奇的體驗。

他們的作品曾在法國、歐洲、巴西、中國、南韓、
加拿大、美國等地的公共空間（建築物投影）和美術
館（裝置藝術）展出。Joanie 曾在柏林國際音樂與視
覺藝術節、上海電子藝術節、紐約實驗媒體與表演
藝術中心、日內瓦的 Mapping 藝術節、onedotzero 藝
術節（全程巡迴）、蒙特樓的 Elektra 國際數位藝術節，
和奧斯陸 Lux 藝術節等活動中展示他的作品。

ARTIST PROFILE
ANTIVJ - JOANIE LEMERCIER

Joanie Lemercier runs the visual label AntiVJ, a project initiated by a group of European visual artists whose work is focused on the use of projected light and its influence on our perception.

Clearly stepping away from standard setups and techniques, AntiVJ presents live performances and installations, providing the audience an experience that challenges the senses and creates wonderment.

AntiVJ have presented work in public spaces (architectural projections) and in galleries (installations) across France, Europe, Brazil, China, South Korea, Canada, USA. Joanie has showcased his work at events like Club Transmediale [Berlin], E-Arts [Shanghai], EMPAC [NY state], Mapping Festival [Geneva], onedotzero festival [London and tour], Elektra [Montreal] and Lux [Oslo] among many others.

作品

APB — ALL POINTS BETWEEN
BY THE LIGHT SURGEONS

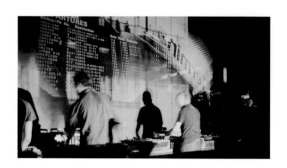

All Points Between 是一部開創性的即興電影表演，由 The Light Surgeons 和 onedotzero 在 2001 年共同創作。該長篇表演彷彿利用一系列聲音和視覺結成的短篇故事，帶觀眾繞行世界一周。它的敘述融合了社會政治論點與數位藝術，反應全球性議題和不同的個人觀點。該作品也是最早反應美國 911 恐怖攻擊事件災後餘波的即興數位藝術作品之一。此作品結合並改編了 The Light Surgeons 的 短 片 Thumbnail Express 和 The City of Hollow Mountains (onedotzero 的委託創作)，並由聽覺藝術家、DJ Scanone 以電子音樂配樂。它在劇場、美術館、多媒體藝術節中以多重畫面的劇場式風格呈現；運用了新與舊的媒體技術，從類比到數位方式混合現場影像，包括 35 厘米幻燈片、16 厘米膠卷放映、影子秀、現場音樂到唱盤主義音樂等。

本作品由 onedotzero 委託創作和開發，自 2001 年至 2003 年曾在世界著名表演場地，如舊金山現代美術館活動中巡迴演出。 一同參與演出的視聽藝術家 包 括：Christopher Thomas Allen、Jude Greenaway、James Price 和 Robert Rainbow。 整場表演收錄在由日本 Gasbook 出版的 DVDLost Leader 中。在這作品之後也出現了更多視聽和現場電影表演形式的創作，如 The Light Surgeons 的最新作品 SuperEverything*。

本作品由 onedotzero 委託創作和製作。

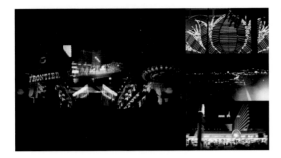

All Points Between was a seminal live cinema project created by The Light Surgeons with onedotzero in 2001. It was a feature length performance which circumnavigated the world through a series of capsule narratives and audio visual tracks. Mixing social-political essay with digital art, the project responded to a range of global issues and different personal perspectives. It was also one of the first live digital art projects to respond to the immediate aftermath of 911.

The project incorporated and exploded The Light Surgeons short films Thumbnail Express and The City of Hollow Mountains [onedotzero commissions] and was woven together with electronic soundtrack by audio artist and DJ Scanone. It was presented as a multi-screen theatrical performance in theaters, galleries and media art festivals. The technical production involved very much traversing old and new media from analogue to digital with live video mixing, 35mm slides sequences, 16mm film projection, shadow play, live music to turntablism. The performance was commissioned and developed by onedotzero and was toured internationally between 2001 and 2003 at such respected venues such as SFMOMA San Francisco and the Moderna Museet Stockholm and festivals like the World Wide Video Festival in Amsterdam.

Collaborating Audio Visual Artists included: Christopher Thomas Allen, Jude Greenaway, James Price and Robert Rainbow. A full documentation of this performance was included on the "Lost Leader" DVD, Published by Gasbook in Japan. The project lead to many more A/V and Live Cinema performances by The Light Surgeons including the recent SuperEverything*.

Commissioned and produced by onedotzero

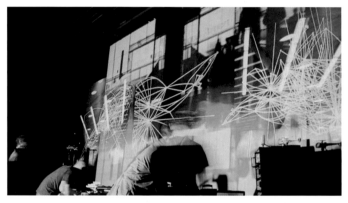

The Light Surgeons 是一間專門從事現場演出、影片製作和裝置藝術的創意企劃公司,自 1995 年由藝術家兼電影工作者 Christopher Thomas Allen 和一群志同道合的英國媒體藝術家共同成立後,就在國際舞臺上頗富名聲,並在不同的創意領域中不斷發展新型態的跨界創作。

The Light Surgeons 從坐落在倫敦東區的工作室中培養了一大群來自不同領域,但是在專業知能上卻可以互補的創意後製人員。透過這群由獲獎紀錄片工作者、動畫家、設計師、軟體開發師所組成的團隊,The Light Surgeons 得以在全世界創作出大量的創新作品。無論是自製的藝術企劃,或是專為滿足客戶的需求,The Light Surgeons 以兼顧製作藝術和產出商業作品而自豪。其擁有超過 15 年的經驗並位居創意產業的領導地位,他們必將持續在藝術和設計領域中邁進。

ARTIST PROFILE
THE LIGHT SURGEONS

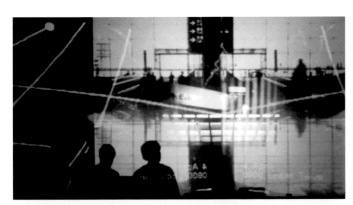

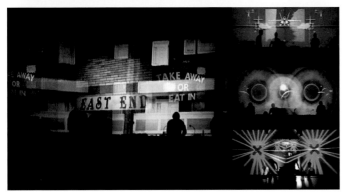

The Light Surgeons are a boutique production company that specialises in creative content for live performance, video production and installation-based projects. The company was founded in 1995 by artist and filmmaker Christopher Thomas Allen with a group of like-minded media artists from the UK. Since then they have become an established creative studio on the world stage, helping to develop new forms of cross-disciplinary practice in the different creative areas that we work in.

From their studio in East London The Light Surgeons have nurtured a wide network of different practitioners that work in the complementary fields of creative audio-visual production and post-production. Through this network of award winning documentary filmmakers, animators, designers and software developers they have produced a multitude of ground breaking projects internationally.

From self-initiated art projects to working to a client's brief, The Light Surgeons pride themselves on producing both art and commercial projects that inform and entertain. With over 15 years of experience as world leaders in the creative industries they continue to push the boundaries between art and design in their work.

作品：
onedotzero GRANIMATOR

Granimator ™是個包含圖案和聲音的創意桌布生成工具，它可以讓使用者自己變成藝術創作者。這個應用程式讓使用者自己選擇桌布上的圖形、風格和背景；而每個圖形則代表一個聲音，可以被操作和自由發揮，使用者可以自行編輯、消除、移動、排列，或去旋轉這些圖案去創作個人化的桌布。

onedotzero 為慶祝成立 15 周年，與數位設計工作室 ustwo ™合作推出 Granimator ™桌布應用程式系列，由 onedotzero 在這 15 年中曾經合作過的一些藝術團隊負責設計。這項合作從 2011 年 11 月的 onedotzero 動態影像藝術節開始進行，目標是在 15 個月內發行 15 個系列。onedotzero 從世界各地選出優秀的設計團隊來擔任設計，目前作品已經可以被下載的或是即將發行的團隊包括：

H5（巴黎）
該法國平面與動畫設計工作室將一些名言錦句轉化為俐落的黑白造型，並且可以被解構而創造出圖案和新的意義。

3KG(札幌)
一群專攻平面設計、插畫、互動與動態影像的設計師，將平面設計手法運用在他們的 granimator 系列。他們將一些用色大膽的幾何形狀組合起來，搭配 Yuri Miyauchi 獨特的聲音設計，簡單的素材和顏色可以創造出的變化令人驚艷。

Grant Orchard（倫敦）
榮獲英國金像獎和聖丹斯電影獎的動畫設計師 Grant Orchard 為 Granimator 設計了生動活潑而有趣的 Yeah Just There，其隱喻了許多代表性愛的圖形，而以一種帶些漫畫式的戲謔，卻又帶些拘謹的衝突呈現出其幽默的風格。

Hideyuki Tanaka(東京)
來自於 Frame Graphics 設計公司，一個多面向的藝術創作者，其作品橫跨時尚、印刷、遊戲、動畫和電影…等。其靈感來自於當今亞洲較俱象徵性的圖案、圖像和聲音素材，當中包括像是卡拉 OK、電玩工業、漫畫以及佛學。

Punga(布宜諾斯艾利斯)
擁有獨特想法的合作系設計工作室，此次與 Granimator 的合作維持一貫作風推出企劃角色，其為一個罹患強迫症與人格扭曲的變態殺手，使用者可以重新將死掉角色的肉塊去重組新人物！

PROJECT
onedotzero GRANIMATOR COLLECTION

Granimator™ is a creative graphics and sound based wallpaper creator that allows the user to become the artist. The app allows the user to select from a choice of shapes, styles and backgrounds. Each shape represents a sound that can be manipulated and played and users can draw, erase, move, scale and rotate these assets to create compositions.

To celebrate its 15th year, onedotzero teamed up with ustwo™ to launch a collection of Granimator™ packs created by some of the artists it has worked with or showcased over the last decade and a half. The collaboration launched at onedotzero_adventures in motion festival in November 2011 with the aim to release 15 over 15 months. A range of talent was curated and selected from all over the globe. Packs available and up coming include:

H5 [Paris]
The French graphics and animation studio converted iconic quotes into slick black and white shapes that can be deconstructed to create patterns and new meanings.

3KG [Sapporo]
The collective of designers working across graphic design, illustration, interactive and moving image took a very graphic approach to their granimator pack. Teaming geometric shapes in bold colours with sound design by Yuri Miyauchi, the diversity that simple objects and colours can create is amazing.

Grant Orchard [London]
The BAFTA and Sundance award winning designer/ animator Grant Orchard presents a fun and saucy Granimator pack called Yeah Just There with a mélange of vaguely erotic shapes that take a slightly comic and tongue in cheek twist.

Hideyuki Tanaka [Tokyo]
The multiple talent from Frame Graphics who specialises in art direction across fashion, print, games, animation and film takes pop visual icons and sounds inspired by contemporary Asia, including Karaoke, NES, Manga and Buddha.

Punga [Buenos Aires]
The collaborative design studio with a unique vision brings out its Psycho killer side with an obsessive-compulsive disorder twist. Re-order and create new characters from chunks of dead ones!

Motomichi Studio(布魯克林)
以創新人物角色為主的專業作品成名，Motomichi Nakamura 以日本傳統風格的美學，運用黑、白、紅三色創造了一個令人不安的深海世界和不明的神秘生物。

Lobo(聖保羅)
作為第一批來自南美的 Granimator 創意團隊，動畫工作室 Lobo 的作品靈感取材自巴西的民間傳說，同時也分享他們對民族神話、幻想中的生物、怪物和奇珍異獸的熱愛，因此創造出這一列名為 Guará 的奇幻圖案，從而時獲大獎。

Universal Everything(雪菲爾)
Universal Everything 是個多面向的創意工作室，作品橫跨設計和藝術，如為品牌、螢幕、美術館和大型運動場等不同對象創作。他們設計的 Granimator 可以讓使用者自行創造生物，僅需於將眼睛貼在各種顏色上的幾何圖形，就可以創造出粗略原始到細緻精巧的物種。

Fred & Company(倫敦)
Fred & Company 是一個具有極新視野的企業，致力於社會和藝術創意相關活動，由跨媒體設計公司 Airside 的共同創辦人暨創意總監，同時也是檸檬果凍樂團 (Lemmon Jelly) 團員之一的 Fred Deakin 所經營。受到最近在巴黎展出的裝置藝術 Electricity Comes From Other Planets 之啟發，該公司設計的 Granimator 讓使用者以層層疊疊的幾何圖形作出有如萬花筒般的曼陀羅圖形。

Cassette Playa(倫敦)
CASSETTE PLAYA 是由時尚設計師 Carri Munden 所創立的品牌，鬥於虛實世界之間的男女所著用之鮮豔制服」。 她的 Granimator 以圖騰為主，引用了她帶有前衛次文化風格的作品與其經典的圖案主題。

Richard Hogg(倫敦)
有插畫家、設計師和電玩設計師和氣球造型創作，他設計的 Granimator 塞滿了閃電、愛心、眼睛、箭頭等圖案，反應了他有趣和好玩的天性。

Trevor Jackson(倫敦)
Trevor Jackson 在視聽文化領域已有 20 年以上的工作經歷。這位倫敦的藝術總監、設計師、動態影像製作人的作品曾經在當代藝術中心、波蘿的海當代藝術中心、古根漢美術館和巴比肯藝術中心展出，並曾出現在無數創新的唱片封面上。

Intro(倫敦)
成立於 1988 年，帶著非傳統的創意和想法，專精設計、企劃與製作，並擁有廣大客戶和合作夥伴。

除此之外，onedotzeo 在近期內還將宣布另外兩個藝術家將在 2013 年完成的系列設計。

Motomichi Studio [Brooklyn]
Renowned for character driven work, Motomichi Nakamura presents a deep-sea world of unnerving and mystical creatures in his signature black, white and red palette with a Japanese infused aesthetic.

Lobo [Sau Paulo]
As one of the first South American Granimator creators, the award-winning graphic design and animation studio Lobo drew inspiration from Brazilian folklore and a shared love of mythology, imaginary beings, monsters and strange creatures to create layers of fantastical illustrations, called Guará.

Universal Everything [Sheffield]
Universal Everything is a diverse studio at the crossover between design and art - creating works for brands, screen, galleries and stadiums. For their Granimator pack you can create creatures from primitive pods to elaborate ecosystems by sticking eyes onto colourful geometric shapes.

Fred & Company [London]
Fred & Company is a new venture focused on social and artistic creative projects driven by Fred Deakin - co-founder and creative director of the ground breaking cross-media design agency Airside and one half of the band Lemon Jelly. Inspired by the recent "Electricity Comes From Other Planets" installation in Paris, this pack allows you to create kaleidoscopic mandalas from layers of geometric circles.

Cassette Playa [London]
Cassette Playa is the label of fashion designer Carri Munden whose work is described as "a toxicolour uniform for hard boys and girls battling real and virtual worlds". Her totemic inspired pack draws on her archive of icons and motifs inspired by contemporary sub-cultures.

Richard Hogg [London]
Illustrator, designer and videogames maker Hogg likes to work with old fountain pens, computers, screen printing, giant murals, and balloon sculptures. His fun and playful nature is reflected in a pack rammed full of illustrative thunderbolts, hearts, eyes, arrows and more.

Trevor Jackson [London]
Trevor Jackson has been working at the forefront of audio and visual culture for over 20 years. The London based art director, designer, moving-Image maker and producer's work has been exhibited at the ICA, Baltic, Guggenheim and Barbican, as well as on countless, seminal record covers.

Intro [London]
The purveyors of creative thought and unorthodoxy since 1988 Intro specialize in design, direction and production and boast an impressive rostrum of clients and partner.

Two more talents to be announced shortly will complete the collection in 2013.

作者介紹
USTWO™

ustwo™是一個提供開創性使用者體驗的數位設計工作室，並吸引了諸如 Sony、Sony Ericsson、Intel、H&M、BBC、Turner 和 J.P.Morgan 等世界級名牌的忠實客戶。

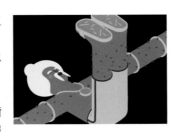

雖然作為獨立公司，但 ustwo™憑藉倫敦和瑞典馬爾摩（紐約據點即將營運）的據點為遍及全球的客戶服務。除了開發自己的應用程式與 IP 專案，他們也參與如 Granimator 這樣的合作作品。

以「讓使用者愛上數位」為己任，他們的業務範圍包括互動型態搭配使用者介面的設計，以及相關應用程式和數位娛樂的開發。他們的設計範圍遍及多種平臺如手機、平板電腦及電視等，而市場面向則橫跨行動裝置、消費性電子產品、零售、娛樂、醫療和金融等產業。

ustwo™從事手機和電視相關開發工作已有六年，除了為客戶開發數位設計和創新，他們也利用生產自己的數位娛樂產品為途徑，如遊戲、應用程式和數位出版等，以進行創新科技的探索與投入。

ARTIST PROFILE
USTWO™

Ustwo™ is a digital design studio that delivers pioneering user experiences as digital partner to the world's leading brands including Sony, Sony Ericsson, Intel, H&M, BBC, Turner and J.P.Morgan.

Boldly independent, they serve a global client base from their studios in London and Malmö, Sweden (New York coming soon). They also generate their own self-initiated projects across apps, IP and collaborative work like Granimator.

Driven by a 'love digital' mission, they specialise in interaction & user interface design, app development and digital entertainment. They design multi-platform experiences across mobile, tablet, TV and beyond across a range of markets including mobile, consumer electronics, retail, entertainment, medical and financial.

ustwo™ have been in mobile and TV for over six years. As well as bringing the very best in digital design and innovation to their clients, ustwo™ explore and invest in new technologies by producing their own digital entertainment in the fields of gaming, apps and publishing.

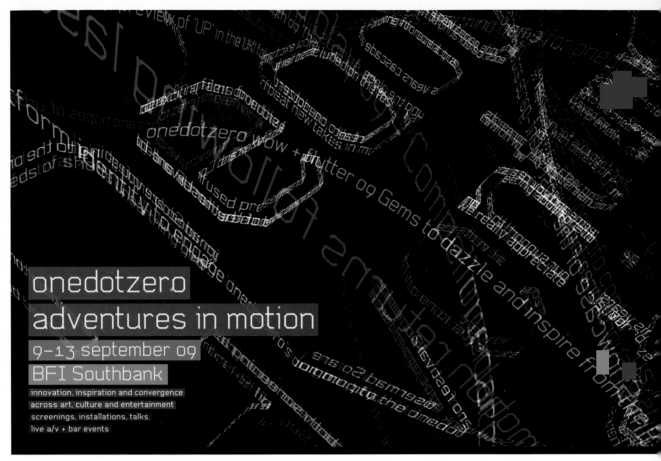

作品：

2009 onedotzero 動態影像藝術節活動意象

onedotzero 動態影像藝術節的中心精神「匯聚和合作」激發了 Wieden & Kennedy 一系列的創意靈感，其注意到 onedotzero 在全球不少的支持者會於社群網站、部落格等平臺發起想法與對話，故進而思索如何將其匯集利用。而 onedotzero 也為其活動意象，特別撰寫了一套可隨機生成並記錄視覺效果的系統引擎，用以搭配創意，製作預告短片以及海報等活動宣傳物件。

Karsten Schmidt(又名 Toxi，Postspectacular 設計工作室)則設計開發軟體，將從社群網站上收集到的文字和意見導入其中，並將其轉化為排列有序且色彩繽紛的字串，其像遵循一條條隱形的路線移動，到最終組合成 onedotzero 的 logo 字樣。

這個軟體可以被隨時暫停以生成用於印刷的素材，或是被截錄下來製成影片。該作品以 50 公尺的互動式裝置形式，於英國電影協會的南岸影院現場播放，觀眾可以透過現場的 Nokia 手機輸入文字訊息，這個開放式源碼軟體也可以被自由下載 和改寫。 而此活動意象也激發了 onedotzero 在倫敦維多利亞與亞伯特博物館舉辦的「解碼 – 數碼設計新官感」展覽中，關於開放源碼、生成式活動意象的靈感。

設　計：Wieden+Kennedy 和 Karsten Schmidt (PostSpectacular 公司)
創意總監：Tony Davidson、W+K London 和 Shane RJ Walter (onedotzero 公司)
創意團隊：David Bruno、Tom Seymour、Karen Jane、Eze Blaine 和 Sermad Buni、W+K London
本作品由 onedotzero 委託創作。

PROJECT
onedotzero_ADVENTURES IN MOTION 2009 IDENTITY

For the onedotzero festival identity a generative engine was authored for producing a series of randomized visual systems, which were recorded for use in the trailer and festival posters.

The heart of onedotzero's festival ethos is 'convergence and collaboration'. This inspired the agency Wieden & Kennedy to create a concept, which harnessed online conversations on social networks and blogs stimulated by onedotzero's global community.

Words and opinions aggregated from social networks were channelled by a bespoke software (that was devised by computational designer Karsten Schmidt aka Toxi of Postspectacular). Colourful strands of live text behave organically, gravitating towards invisible paths, which ultimately form the onedotzero logo.

The software can be paused to create print assets or recorded to create film assets. It also ran live as a 50m interactive digital installation for the launch at the BFI Southbank, where visitors could input the text of their choice via brand new Nokia handsets. The open source software is freely available to download and adapt. This identity inspired the open source, generative identity for Decode: Digital Design Sensations Exhibition at the V&A Museum in collaboration with onedotzero.

Designed by Wieden+Kennedy and Karsten Schmidt, PostSpectacular
Creative Directors: Tony Davidson, W+K London and Shane RJ Walter, onedotzero.
Creative Team: David Bruno, Tom Seymour, Karen Jane, Eze Blaine and Sermad Buni, W+K London

Commissioned by onedotzero

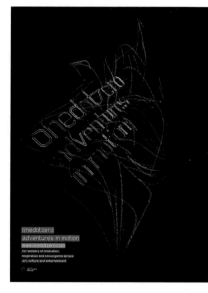

作者介紹

Wieden+Kennedy
Wieden+Kennedy 是全世界唯一的一個
獨立、創意導向的全球性公司。他們在
倫敦的辦公室成立於 1998 年，目前有
超過 150 名的員工，他們的客戶包括
Nokia、Honda、Nike 和 Space NK 等。

Karsten Schmidt aka Toxi
Postspectacular 是由 Karsten Schmidt 在
倫敦創立的小型設計工作室暨顧問公
司。其積極著力在不同背景下的設計、
藝術以及軟體開發間探索更多可能性。

ARTIST PROFILE
WIEDEN+KENNEDY

KARSTEN SCHMIDT AKA TOXI

Wieden+Kennedy is the world's only independent, creatively led global agency. The London office was founded in 1998, which has grown to over 150 people. Their clients include Nokia, Honda, Nike and Space NK.

Postspectacular is a small London based design studio and consultancy founded by Karsten Schmidt to actively explore the growing possibilities at the intersection of various design disciplines, art and software development in a multitude of contexts.

作品：
BLOOM

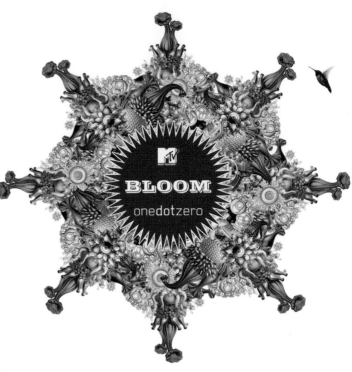

2007 年 onedotzero 和 MTV 頻道合作，強力推出 Bloom 這個尋找創意新興人才的比賽。邀請剛嶄露頭角的電影製片、動畫師和創意人才製作一分鐘的短片，主題是以新穎的角度探索自己居住城市的特色和人群，以顛覆過往大家對它們的刻版印象。

總計有來自澳洲、歐洲、非洲、南美洲、亞洲 30 幾個國家的 200 多名參賽者報名。 評審團選出了分別來自奧克蘭、北京、羅馬、紐約、倫敦、卑爾根、華沙、洛杉磯、巴黎和雪菲爾的 10 名優勝者，另外還有來自東京、倫敦、布加勒斯特和荷蘭的 5 名入選者。

評審們主要針對參賽者對於 Bloom 主題的創新、風格、技巧和創意表現程度進行評選，10 支優選的影片則由 onedotzero 贊助製作。這些已製作完成的一分鐘短片在 2008 年於全球 100 多個 MTV 頻道和網路上大量密集播出。

本作品創意總監兼製作人，Shane RJ Walter 表示，「Bloom 這個作品代表的正是 onedotzero 的經營主軸 - 即進行創意合作、發掘新興人才，並以放遠的眼光觸及廣大的國際觀眾。MTV International 是優秀的合作

夥伴，而這 10 名勝出的創意人才證明了品質加上創新可以成就 10 件小型的傑作。」

創意總監：Cam Levin (MTV International), Shane RJ Walter (onedotzero)
製作人：Shane RJ Walter、Anna Doyle、Sam Pattinson

本作品由 onedotzero 製作。

PROJECT
BLOOM

In 2007 onedotzero and MTV joined forces to create the Bloom project - a competition which searched for the very best up-and-coming creative talent. New filmmakers, animators and creatives were invited to send a treatment for a one-minute film that explored the identity and community of their hometown in a fresh way, challenging national stereotypes.

In total there were over 200 entries from over 30 countries all around the world across Australia, Europe, Africa, South America and Asia, entered. The judging panel selected 10 winning entries from Auckland, Beijing, Rome, New York, London, Bergen, Warsaw, Los Angeles, Paris and Sheffield. Five runners-up were from Tokyo, London, Bucharest and the Netherlands.

The entries were judged on innovation, style, technical skill and creative interpretation of the Bloom brief. The ten winning treatments went on to be made with production support from onedotzero. The finished one-minute films were given massive airtime coverage across MTV's network on over 100 channels globally and online in 2008.

"The bloom project represents exactly what onedotzero is about - creative partnership, new talent, progressive vision reaching a wide international audience. MTV International are the perfect partners and the 10 winning creative talents exemplify quality twinned with innovation producing 10 brilliant mini-masterpieces," Shane RJ Walter, onedotzero.

Credits:
Creative Directors: Cam Levin [MTV International], Shane RJ Walter [onedotzero]
Producers: Shane RJ Walter, Anna Doyle, Sam Pattinson

A onedotzero production

1. Quayola：Rome（義大利 羅馬）

2. Lulu Li：Beijing Dance（中國 北京）

3. Ayala Sharot：Foreigners（英國 倫敦）

4. Matt Bullock：Cityfix（英國 雪菲爾）

5. Igor Knezevic：Proxies（美國 洛杉磯）

6. The Holograms：Morfism（法國）

7. Przemyslaw Adamski / Katarzyna Kijek：Untitled（波蘭 華沙）

8. Ryan Louie：Untitled（美國 紐約）

9. Marieke Verbiesen：Nordic Folk Legends（挪威 卑爾根）

10. Neil Grundy and Alyssa Kath：Lone Kauri Road（紐西蘭 奧克蘭）

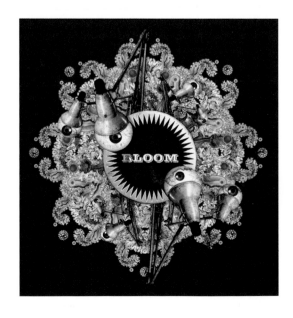

ARTIST PROFILE
BLOOM WINNING FILMMAKERS

1. Quayola: Rome [Rome, Italy]
2. Lulu Li: Beijing Dance [Beijing, China]
3. Ayala Sharot: Foreigners [London, UK]
4. Matt Bullock: Cityfix [Sheffield, UK]
5. Igor Knezevic: Proxies [L.A., USA]
6. The Holograms: Morfism [France]
7. Przemyslaw Adamski / Katarzyna Kijek: Untitled [Warsaw, Poland]
8. Ryan Louie: Untitled [N.Y.C, USA]
9. Marieke Verbiesen: Nordic Folk Legends [Bergen, Norway]
10. Neil Grundy and Alyssa Kath: Lone Kauri Road [Auckland, New Zealand]

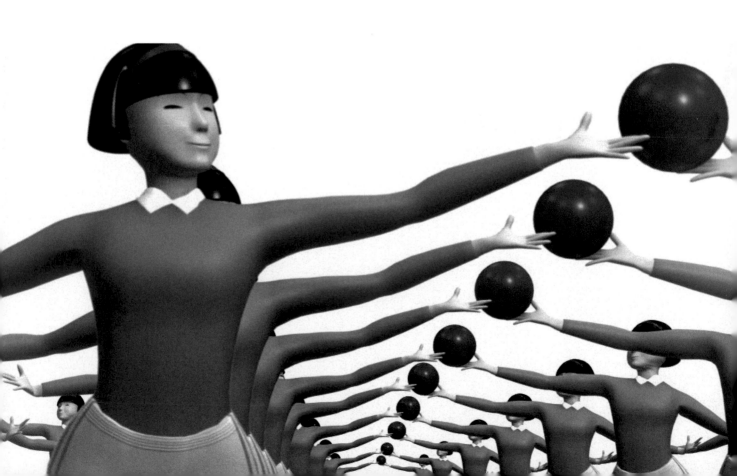

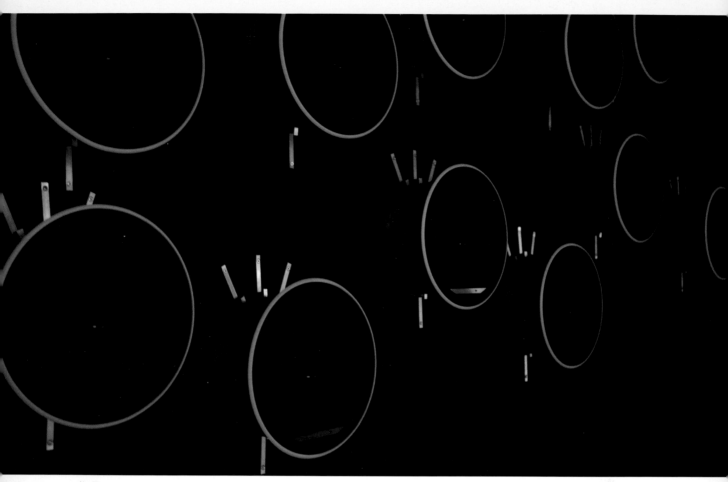

作品：
PLASTICITY

Plasticity 是以聲音裝置 Fragmented Orchestra 獲得 PRS 音樂協會獎的創意團隊，
與 Kin 設計工作室近期合作的作品，它是一個針對特定區域的聲光互動裝置，由
一排擴音器、麥克風和 led 燈排列組合而成，接收到觀眾發出的聲音和環境聲音
的刺激時就會啟動。

這個藝術裝置由一排分散的麥克風和一組固定在牆面上的擴音器所組成。一旦
觀眾對麥克風發出聲音，裝置就會直接作出反應，被環境中的聲音所啟動。
Plasticity 發展經過一段時間後，原先沒有出現的模式和反應會隨著裝置進化衍
生，創造出獨特的聲音、視覺體驗。

由 Tim Hodgson 擔任音響 / 數位訊號處理、John Nussey 擔任技術支援，
Plasticity 在 2011 年 onedotzero 的動態影像藝術節中於英國電影協會首次展出。
並由英國音響品牌 Bowers & Wilkins、普利茅斯大學和英國文化協會贊助支持。

本作品由 onedotzero 委託創作。

PROJECT
PLASTICITY BY JANE GRANT, JOHN MATTHIAS, NICK RYAN, KIN

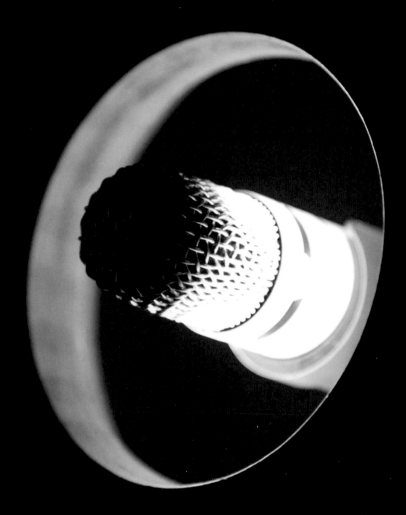

The creators of the PRS Award winning Fragmented Orchestra project in collaboration with design studio Kin present their latest collaboration, Plasticity, a site-specific project that invites users to interact with an audio-visual installation. An array of speakers, microphones and led lights are arranged as the network comes alive in direct response to visitor inputs, stimulated by the sounds within the environment.

The installation consists of an array of microphones distributed and a network of speakers, arranged across a wall. The network comes alive in direct response to visitor input into the microphones and is in effect stimulated by the sounds within the environment. Plasticity develops over time with previously unheard patterns and connections emerging as the installation evolves, creating a unique sonic and visual experience.

Audio/DSP developer was Tim Hodgson and support from technologist John Nussey. Plasticity was premiered at onedotzero_adventures in motion at the BFI Southbank, London in 2011, sponsored and supported by Bowers & Wilkins, the University of Plymouth and the Arts Council.

Commissioned by onedotzero

Kin 設計工作室
因為相信在藝術方向和互動設計方面可以有機會發
展出更靈活的手法，Kevin Palmer 和 Matt Wade 於
2008 年 4 月共同成立該工作室。
www.kin-design.com

Nick Ryan
獲獎無數的藝術工作者，身兼音效創作、編曲人、藝
術與聲音媒體的奇才，他以對聲音與音樂的獨特處理
手法而聞名。其作品包含電玩、電視、劇情片、劇場、
音樂會、音樂專輯、裝置和互動藝術等產出。
www.nickryanmusic.com

Jane Grant
致力於動態影像、音效、裝置藝術、繪畫與寫作的一
名藝術家，並常與科學家、設計師和作曲家進行跨領
域合作。
www.janegrant.org.uk

John Matthias
與 Jane Grant 和 Nick Ryan 以大型聲音裝置作品
Fragmented Orchestra 獲得 PRS 音樂協會獎新音樂獎
（相當於音樂界的透納獎）的音樂家、作曲家。

Kin Design
Design studio established in April 2008 by Kevin
Palmer and Matt Wade with the belief that there is
opportunity to develop smaller more agile approach
to art direction and interaction design.
www.kin-design.com

Nick Ryan
A multi award winning sound designer, composer,
artist and audio media specialist widely recognised
for his unique approach to sound and music. His
work has included and traversed a range of outputs
including computer gaming, TV, feature films, theatre,
concerts, recording releases, installations and
interactive projects.
www.nickryanmusic.com

Jane Grant
An artist who works with moving image, sound,
installation, drawing and writing, working across
disciplines in the arts and sciences often collaborating
with scientists, designers and composers.
www.janegrant.org.uk

John Matthias
An award winning musician and composer who won
the PRS Foundation new music award [the musical
equivalent of 'the Turner Prize'] for the development
of a huge sonic installation entitled the Fragmented
Orchestra [with Jane Grant and Nick Ryan].

專題報導

FEATURES

關於
onedotzero

onedotzero 是一個以創新藝術、設計、科技和娛樂領域為中心的文創工作室，透過大型活動、動態影像、出版、策展、展覽、委託創作和創意製作等，為我們的觀眾，以及全球的合作夥伴提供創新的企劃。

出於對動態影像和現場視聽產品的遠見，以及致力於透過屏幕體現互動技術的探索，onedotzero 創始於家用電腦革新時期的 90 年代中葉。 今日，onedotzero 依然在為具有遠見的動態影像實驗以及現代創意思想提供一個交流的基地。

onedotzero 與藝術機構、博物館、藝術節、品牌、教育家、和客戶們一起努力；以結合優秀人才、智慧科技和極佳的創造力，開發並加以策劃相關活動、建構和製作創新的創意作品。

onedotzero 的成立建構在合夥、合作、創意匯流和冒險精神的力量上；且擁有頂尖的國際視野、科技知識，並與其提供靈感或找尋靈感的族群建立緊密的關係。而在全球盟友、工作夥伴、展演空間、藝術創作者和技術人員脈絡皆遍及文化與創意產業。

我們相信，當今這些致力支持於發展與開拓數位文化的耕耘者，會因透過創意、創新，與分享而獲得廣泛的尊重。而我們也通過對於創新的渴望，極力發展並創作出國際級的文化相關作品，進而傳承更多令人意想不到的可能性，像是讓人們無論透過網路、傳統媒體上或是於博物館、夜店，甚至街道上和教室裡，都可以輕易參與作品其中的創意環節。

這些經驗為觀眾和客戶都創造出難以衡量的價值，為今日的文化帶來重大影響也是無庸置疑的。營運超過 15 年，onedotzero 在數位文化領域的成就橫跨了兩個世紀，並在全球超過 150 個城市中傳遞。

自創立以來，由 onedotzero 透過其策劃的藝術節、大型活動、影像 DVD 或其他專案，整理出數百小時的原始素材。故 Onedotzero 的 DVD 系列自 2001 年開始發行，並以 5 部曲呈現於全球各處販售，內容以介紹來自全球各地最先進、前衛的動態影像為主。

onedotzero 在 2008 年推出 Shane RJ Walter 的 DVD 叢書「Motion Blur II：動態影像的製作」，在全世界發行熱銷。其為 2005 年「Motion Blur：動態影像的製作」一書的續集。

除了短片之外，onedotzero 協助英國 Channel 4 頻道，製作並執導了優質電視節目 onedottv 和 onedottv_global。並受託創作相關互動媒體、裝置藝術、展覽和現場視聽展演，其中也包括無數的得獎短片。

Onedotzero 參與了 「解碼 - 數碼設計新感官」展覽的共同策畫，該展覽於倫敦維多利亞與亞伯特博物館展出。其展示了當代數位和互動設計的最新發展，從小螢幕平面設計到大型藝術裝置都在其中。這個展覽曾到北京中央美術學院、莫斯科格拉吉當代藝術中心和特拉維夫霍龍設計博物館作出巡迴。

onedotzero industries 是 onedotzero 的姊妹製作公司，它為世界知名的品牌和樂團提供顧問諮詢與進行相關製作如 Intel、Nike、MTV、Google、U2 、Lady Gaga、Pet Shop Boys、George Michael 等，並為 Dentsu, Ogilvy、Wieden + Kennedy 和 Mother 等不同公司製作創新的裝置藝術、動畫、繪圖、印刷和動態圖像等跨領域視覺作品。

ABOUT onedotzero

Onedotzero is a creative cultural studio motivated by innovation in art, design, technology and entertainment delivering progressive projects across events, moving image, publishing, curation, exhibitions, commissions and production for ourselves, our audience or with partners across the globe.

onedotzero was conceived at the start of the desktop digital revolution in the mid-1990s out of a desire to explore moving image across single screen, interactive and live audio-visual work. Today, onedotzero remains committed to providing a home for visionary moving image experimentation and contemporary creative collisions.

onedotzero works with agencies, museums, festivals, brands, educators, and clients; partnering, curating, building and producing innovative creative work that use and fuse great talent, smart technology and fantastic creativity to create culturally relevant projects.

onedotzero was founded on the power of partnership, collaboration, creative convergence and a sense of adventure. We have an international perspective, understanding of technology and direct relationship with a community looking to inspire and be inspired. Our global network of friends, partners, venues, artists, creators and technologists, span the cultural and creative industries.

We believe today's audiences respects those who support, develop and engage with digital culture, through creation, innovation and sharing. We have a desire to create culturally relevant work that is world class, credible, and leaves a legacy of excitement about what is possible. We want to produce work that makes a difference that people want to be a part of whether online or onscreen, in a museum or nightclub, from the street to the classroom.

These experiences create value for both audiences and clients, value that cannot always be measured but is indisputable by its impact on today's culture. Operating over 15 years, onedotzero's track record is unique – delivering digital culture over two centuries in over 150 cities worldwide.

Since its inception, onedotzero has collated and commissioned hundreds of hours of original programming for its festival, events, DVD's and other projects. The onedotzero DVD label, launched in 2001, is distributed and sold around the world. onedotzero select DVD's 1-5 are available worldwide, featuring a compilation of the most progressive moving images from around the world.

The book onedotzero 'Motion Blur 2: Multidimensional Moving Imagemakers' and accompanying DVD by Shane RJ Walter was released in 2008 to critical acclaim, and is available worldwide. This was a follow up publication to the successful and 'Motion Blur: Graphic Moving Imagemakers', produced in 2005 that has been reprinted and sold globally.

In addition to short film, onedotzero has produced and directed the standout TV series 'onedottv' and 'onedottv_global' for the UK's Channel 4, and has produced and commissioned interactive media, installations, exhibitions and live AV shows and numerous awarding winning short films.

onedotzero co-curated Decode: Digital Design Sensations, an exhibition at the V&A Museum, London, which showcased the latest developments in digital and interactive design, from small screen based graphics to large-scale installations. This toured to CAFA Beijing, The Garage Moscow and Holon Design Museum Tel Aviv.

onedotzero industries is the sister company which produce and consult for the world's best-known brands and bands from Intel and Nike to MTV and Google, U2 and Lady Gaga to the Pet Shop Boys and George Michael in addition to various agencies like Dentsu, Ogilvy, Wieden + Kennedy and Mother producing innovative multi-disciplinary work across visuals, installations, animation, print and motion graphics.

關於德國 ZKM 藝術媒體科技中心

德國 ZKM 藝術媒體科技中心 (Center for Art and Media) 的成立可以追溯到 1980 年,當時藝術媒體科技中心的概念還處於萌芽階段。直到 1986 年,卡斯魯爾市 (Karlsruhe) 的政界人士、大學代表、國立音樂學院、核子研究中心才和其他相關機構共同成立了一個計畫團隊,推動一個稱為「Concept 88」的實驗計畫,嘗試從新理論與實驗的角度,連結藝術與新媒體科技這兩個領域。

1988 年巴登 - 符騰堡州州長洛塔爾· 施佩特推動政府投入資源建造科技媒體藝術中心,並於 1989 年任命 Prof. Heinrich Klotz 為總監,自此科技媒體藝術中心逐漸成形。

原本規劃將 ZKM 藝術媒體科技中心設置在卡斯魯爾市火車站南邊的新展館裡,並邀請荷蘭建築師規劃設計,但因提出的方案成本遠遠超過預算,故經過漫長的討論,州政府最後決定放棄興建,而改以舊建物再造的方式,將大型的舊軍火工廠 "Industrial Works Karlsruhe Augsburg" 改造成為 ZKM 藝術媒體科技中心的基地。第二次世界大戰時,這座建築物曾被用來製造潛艇水雷、炸藥等武器。其改建、翻新的工作由建築師 Schweger & Partner 負責,他們改造這座深具壓迫感,且了無生氣的舊建築,將其從一個被冰冷支配的紀念碑,轉化為一個能完整呈現先進科技和各樣藝術表達的空間。

在 ZKM 的草創及修建時期,雖辦公地點散布在城市各處,但卻在 1997 年正式啟用前,就已透過舉辦的藝術活動讓觀眾感受到 ZKM 的強大創作能量。

作為一個文化機構，ZKM 在全球扮演著獨特的角色地位。它呼應了
現代通訊科技的快速進步和社會結構的變化。結合了創作、研究、
展演、活動、合作及文獻保存。

為了加強跨領域及國際合作，ZKM 擁有當代藝術博物館、媒體博物
館、圖像媒體研究所、音樂與聲音研究所和媒體、教育、經濟研究
所等不同的資源提供運用。

在彼德‧韋貝爾 (Peter Weibel) 的領導下，ZKM 在理論和實踐方面都
深入研究新媒體科技，勘探其內部發展潛力，提供可做為典範的型
式，並挑戰現有的既定模組。

與卡斯魯爾市的州立設計學院和其他機構密切合作，ZKM 為科學、
藝術、政治和財政提供了一個交流的空間。參觀者可以在 ZKM 開放
式的環境中參與活動、導覽、參觀展覽或媒體中心。ZKM 不但是一
個實驗及討論的平臺，也有著積極對於未來科技的理性，及其有效
運用而努力的不凡使命。

The founding of the Center for Art and Media can be traced back to the year 1980, when the idea for a media arts center first came into being. By 1986, a project group had been organized, consisting of local politicians and representatives of the university, the State Music Academy, the Center for Nuclear Research and other institutions in Karlsruhe. In »Concept 88«, they described their vision for bringing together art and the new media in theory and practice.

In 1988, the government of the province of Baden-Württemberg, led by Minister President Lothar Späth, voted to establish the Center for Art and Media as a foundation incorporated under public law. With the establishment of the foundation's council in 1989 and the appointment of Prof. Heinrich Klotz as founding director, the realization of a Center for Art and Media started to take form.

Originally, the Center was to be housed in a new building on a site south of Karlsruhe's train station. However, implementing the plans of Dutch architect Rem Kohlhaas would have exceeded the allotted budget by far. After long and heated debate, the idea of a new construction was abandoned. Instead, a historic monument was chosen - the vast edifice of a former munitions factory, »Industrial Works Karlsruhe Augsburg«, was to become the home of the new Center for Art and Media. During the Second World War, the building was used to produce weapons like torpedoes and explosives. Architects Schweger & Partner undertook planning, reconstruction and renovation, converting a structure of dominating, static monumentality into a building ideally suited to presenting advanced technologies and artistic experiments.

In the early phases of its founding and construction, the Center's offices were scattered across the entire city. Nonetheless, events such as the series "ZKM in the Factory" and the media art festival Multimediale with the Siemens Media Arts Award, gave audiences a chance to experience the broad spectrum of the Center's work even before it opened its doors in 1997.

As a cultural institution, the Center for Art and Media (ZKM) in Karlsruhe holds a unique position in the world. It responds to the rapid developments in information technology and today's changing social structures. Its work combines production and research, exhibitions and events, coordination and documentation.

For the development of interdisciplinary projects and promotion of international collaborations, the Center for Art and Media has manifold resources at its disposal: the Museum of Contemporary Art, the Media Museum, the Institute for Visual Media, the Institute for Music and Acoustics and the Institute for Media, Education, and Economics.

Under the direction of Prof. Peter Weibel since 1999, the Center for Art and Media probes new media in theory and practice, tests their potential with in-house developments, presents possible uses in exemplary form and promotes debate on the form our information society is taking. Working closely with the State Academy for Design in Karlsruhe and other institutes, the Center for Art and Media provides a forum for science, art, politics and finance.

In a spacious ambient, visitors can enjoy events and tours, view public exhibitions or visit the Mediathek. The Center is a platform for experimentation and discussion, with a mission to participate actively in working towards the future and engage in the ongoing debate about the sensible and meaningful use of technology.

3D 電影實驗室 / 卡斯魯爾藝術與設計大學

3D 電影實驗室是世界上獨一無二的一所研究中心，由電影製片人 Ludger Pfanz 在 2010 年春天所創立，Ludger Pfanz 目前於卡斯魯爾藝術與設計大學擔任包括影像、電影、聲音、3D、多媒體和舞臺工作室總監。3D 電影實驗室作為一個介於該大學和 ZKM 之間的研究中心，主要負責研發立體電影、電視、三維立體影像、聽覺藝術等技術。此外，它還包括將景物空間透過新視覺化過程而呈現，如運用雷射科技、衛星、顯微攝影，以及超音波和 x 光波處理。而設立世界上第一個立體影像學位課程則是該機構的首要目標。

擁有來自 Baden-W　rttemberg 教育研究部的支持，再加上自身的資金底，該機構足以提供媲美好萊塢等級的 3D 電影工作技術。從掌握現場執行的實驗階段、無限可能的後期製作，到裸視 3D 立體顯示技術的呈現發展，該機構與 ZKM 已合作建立了自己的 3D 影院。

3D 電影實驗室目前已是國際上認可的研究和教學機構。並於 2010 年參與慕尼黑兒童雙年影展的國際會議；同年則擔任德國電影暨電視製作公司 UFA 執行會議的顧問。也藉由跟推廣文化的電視頻道 ARTE 的密切合作，建立了結合藝術頻道 Souvenirs from the Earth 的平臺。

為確保產出最高品質的成果，3D 實驗室還與 ZKM、卡斯魯爾國際大學、工程數學和運算實驗室、生命週期工程服務中心、卡斯魯爾音樂學院、Schauburg 電影院、卡斯魯爾教育學院等專業單位，組成了 3D 合作聯盟。

總監 Ludger Pfanz 表示，在 2012 年年底，3D 實驗室將會購入一臺價值 120 萬美元的超級電腦來處理極其複雜的數據資料。但對 3D 實驗室來說困難的是，他們沒有辦法去操作這些龐大的數據分析。正因有了 3D 合作聯盟，他們開始與不同知識領域的專家一起工作，使這些來自當地機構、學校的數學家、工程師和科學家們，能難得的一同為藝術賣力。他還介紹了學生的工作室，這些設備皆以具有彈性且可移動式的配置架設，使得他們可以隨時更新設備，就算更動作業人員或因應不同需求工作時，只要簡單的增加電腦和螢幕就可以適應新的需求，藉此延長工作室的實用性和壽命。

3D MOVIES LABORATORY
UNIVERSITY OF ART AND DESIGN KARLSRUHE

3D movies Lab is unique in the world of a research center , by the filmmaker Ludger Pfanz founded in the spring of 2010 , Ludger Pfanz currently at the University of Art and Design Karlsruhe as including images, movies, sounds , 3D, multimedia studio and stage director. 3D movies laboratory as a range between the university and the ZKM Center , is responsible for developing three-dimensional movies, television , three-dimensional images , auditory art technology. In addition, it includes a new visual scene space through the process and present , such as the use of laser technology , satellite, photomicrography , as well as ultrasound and x- light treatment . Established the world's first stereoscopic degree program is the agency's primary goal.

Has come from Baden-Württemberg Ministry of Education support , coupled with the end of their funding , the agency sufficient to provide a comparable level of 3D Hollywood movies work skills . From the master site implementation of the experimental stage, infinite possibilities post-production, to the naked eye 3D stereoscopic display technology presents the development of the agency has been set up in collaboration with ZKM own 3D theater .

3D movies laboratory is already internationally recognized research and teaching institutions . And in 2010 in Munich, the International Children's Film Festival Biennial Conference ; same year, then served as the German film -cum- television production company UFA executive session adviser. Also with the promotion of culture by ARTE television channel close cooperation , the establishment of combined arts channel Souvenirs from the Earth platform.

To ensure the highest quality of output results , 3D Lab also with the ZKM, Karlsruhe International University , engineering, mathematics and computing laboratories, life cycle engineering service center, Karlsruhe Conservatory , Schauburg cinema , Karlsruhe Education and other specialized units , consisting of 3D alliance .

Director Ludger Pfanz said that in the end of 2012 , 3D lab will acquire a value of $ 1.2 million supercomputer to handle extremely complex data . But for 3D labs difficult is that they have no way to operate these massive data analysis. Because alliance with 3D , they started with different fields of knowledge experts to work together to make these from the local institutions, schools of mathematicians , engineers and scientists , to rare hard together for the arts .

He also introduced the student's studio , these devices begin with a flexible and portable configurations set up, so that they can update the device , even if the person changes jobs or work in response to different needs , simply increase the computer and monitor can be adapt to new demands , thereby extending the usefulness and longevity of the studio .

專有名詞索引

INDEX

多媒體（Multimedia）

在計算機系統中，組合兩種或兩種以上媒體的一種人機互動式信息交流和傳播媒體。使用的媒體包括文字、圖片、照片、聲音、動畫和影片，以及程式所提供的互動功能。

新媒體藝術（new media art）

1990 年代後期，隨著數位媒體的崛起與興盛以及電子數位影音產品的普及化，「新媒體藝術」成為更新的辭彙，語意當中更含涉著對於當代藝術以結合或運用「新科技」作為手段的期待。大抵而言，「新媒體藝術」強調對於「新科技」的運用與實驗，俾使其成為藝術表現的一種可能。「新媒體藝術」可以看成是「媒體藝術」的一種延伸，或是一種深化，同時，更加重視「新科技」──譬如方興未艾的數位影音、網際網絡、乃至於互動媒體科技──的運用或應用。

在臺灣，在「媒體藝術」這一辭彙之外，其實另有兩個更常受喜愛的替代名稱，亦即「科技藝術」與「數位藝術」。

短片（Short film）

北美電影工業在電影誕生的早期所誕生的一個片種。通常在北美將長度介於 20 到 40 分鐘的電影稱作短片，而在歐洲、拉丁美洲和澳洲則可以更短一些，比如紐西蘭將長度介於 1 到 15 分鐘的電影稱作短片。

在現今的電影界並沒有對一部短片的長度上限作出明確的規定。美國電影藝術與科學學院將影片長度設定為 40 分鐘，網際網路電影資料庫則設定為 45 分鐘。

裝置藝術（Installation art）

裝置藝術是一種興起於 1970 年代的西方當代藝術類型。裝置藝術混合了各種媒材，在某個特定的環境中創造發自內心深處的或概念性的經驗。裝置藝術家經常會直接使用展覽場的空間。由於裝置藝術擁有 1960 年代觀念藝術的根源，在大多數的裝置藝術中，藝術家的強烈張力扮演了極為重要的角色。這個特色讓裝置藝術與傳統雕塑的距離又更遠了些，因為後者是著重於形式。裝置藝術使用的媒材包含了自然材料到新媒體，比如錄影、聲音、表演、電腦以及網路。

有些裝置藝術屬於場域特定藝術（Site specific art），它們只能存在於它們被創作出來的那個空間中。在紐約的新當代藝術博物館就經常展出這樣的作品。

軟實力（Soft Power）

指國際關係中，一個國家所具有的除經濟、軍事以外的第三方面的實力，主要是文化、價值觀、意識形態、民意等方面的影響力。「軟實力」的概念是由美國哈佛大學教授約瑟夫·奈爾提出來的。根據約瑟夫·奈爾的說法，硬實力是一國利用其軍事力量和經濟實力強迫或收買其他國家的能力，軟實力則是「一國透過吸引和說服別國服從你的目標從而使你得到自己想要的東西的能力」。約瑟夫·奈教授認為一個國家的軟實力主要存在於三種資源中：「文化（在能對他國產生吸引力的地方起作用）、政治價值觀（當這個國家在國內外努力實踐這些價值觀時）及外交政策（當政策需被認為合法且具有道德威信時）」。美國學者尼古拉斯·歐維納則認為：「軍事以外的影響力都是軟實力，

包括意識形態和政治價值的吸引力、文化感召力等。」《論語》季氏篇夫子曰：「遠人不服，則修文德以來之」，「文德」即是軟實力。類似的概念有巧實力等。

Twitter（非官方中文譯名推特）

一個社群網路和一個微網誌服務，它可以讓使用者更新不超過 140 個字元的訊息，這些訊息也被稱作「推文（Tweet）」。這個服務是由傑克·多西在 2006 年 3 月創辦並在當年 7 月啟動的。Twitter 在全世界都非常流行，據 Twitter 現任 CEO 迪克·科斯特洛 (Dick Costolo) 宣布，截至 2012 年 3 月，Twitter 共有 1.4 億活躍使用者，這些使用者每天會發表約 3.4 億條推文。同時，Twitter 每天還會處理約 16 億的網路搜尋請求。Twitter 被形容為「網際網路的簡訊服務」。網站的非註冊使用者可以閱讀公開的推文，而註冊使用者則可以透過 Twitter 網站、簡訊或者各種各樣的應用軟體來發行訊息。

互動設計 (Interaction Design)

互動設計，又稱交互設計，（英文 Interaction Design, 縮寫 IxD 或者 IaD), 是定義、設計人造系統的行為的設計領域。人造物，即人工製成物品，例如，軟體、移動設備、人造環境、服務、可佩帶裝置以及系統的組織結構。互動設計在於定義人造物的行為方式 (the "interaction", 即人工製品在特定場景下的反應方式）相關的界面。

唱盤主義 (Turntablism)

一種使用兩臺唱盤跟一臺混音器來製作聲音還有音樂的藝術型態。1994 年由 DJ Supreme 創造出這名詞，來界定 club DJ 和真的把唱盤當作樂器在表演的 DJ 的差別。而 turntalist 就是這類型的 DJ。DJ badu 如是説：一個可以利用唱盤作即興演奏；一個將唱盤完全當作樂器來看待的 DJ 就是 turntalist。

使用者經驗 (User experience)

是一個測試產品滿意度與使用度的詞語，可能是基於西方產品設計理論中發展出來的。在大多數情況下，產品軟體測試或是商業行銷測試時，會用到使用者經驗這個詞。但是它也可應用在互動設計，互動式語音應答上面。有時在探討設計價值時，也會用到此新設計是否導出更差的使用者經驗，來評估其好壞。

國家圖書館出版品預行編目資料

新媒體藝術 / 國立臺灣師範大學文化創藝產學中心主編.
-- 初版. -- 臺北市：藝術家，2014.03
112 面；20×25.5 公分. -- （文化創意叢書）
ISBN 978-986-282-119-0（平裝）

1.數位藝術　2.數位媒體　3.高科技藝術

956　　　　　　　　　　　　　　102027604

文化創意叢書　**新媒體藝術**

NEW MEDIA ART

著作 / 黃茂嘉、許和捷、Shane Walter

發　行　人　何政廣
主　　　編　國立臺灣師範大學文化創藝產學中心
執 行 編 輯　林佩君、大衛羊駝
美 術 編 輯　Steve Price、Plan-B Studio、黎世堯、江宜荃

出　版　者　藝術家出版社
　　　　　　臺北市重慶南路一段 147 號 6 樓
　　　　　　TEL：(02)2371-9692~3
　　　　　　FAX：(02)2331-7096
　　　　　　01044798 藝術家雜誌社
郵 政 劃 撥　時報文化出版企業股份有限公司
　　　　　　桃園縣龜山鄉萬壽路二段 351 號
　　　　　　TEL：(02)2306-6842
總　經　銷　臺南市西門路一段 223 巷 10 弄 26 號
南 區 代 理　TEL：(06)261-7268
　　　　　　FAX：(06)263-7698
製 版 印 刷　新豪華彩色製版印刷股份有限公司

初　　　版　2014 年 3 月
定　　　價　新臺幣 380 元
I　S　B　N　978-986-282-119-0